DRAWING
Dragons

Barb Weston

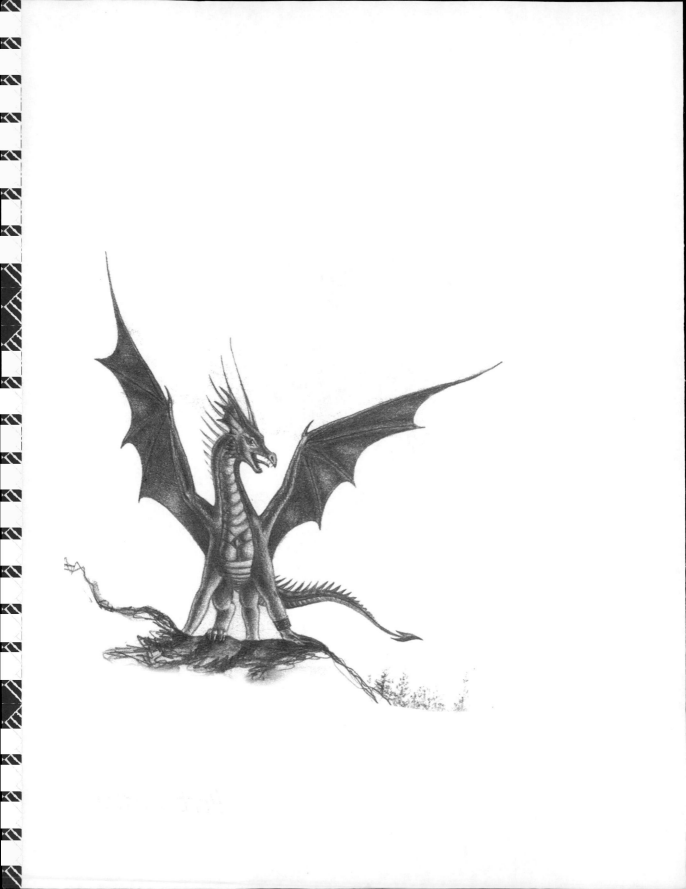

2009

DRAWING

Dragons

Sandra Staple

Learn How to Create Fantastic Fire~Breathing Dragons

Ulysses Press

Published in the United States by
Ulysses Press
P.O. Box 3440
Berkeley, CA 94703
www.ulyssespress.com

ISBN10: 1-56975-641-4
ISBN13: 978-1-56975-641-6
Library of Congress Control Number 2007907743

Printed in Canada by Transcontinental Printing

10 9 8 7 6 5 4 3 2 1

Acquisitions: Nick Denton-Brown
Copy Editor: Mark Woodworth
Production Manager: Steven Schwartz
Design/Production: what!design @ whatweb.com
Production: Tamara Kowalski
Cover Design: what!design @ whatweb.com

Distributed by Publishers Group West

I dedicate this book to every person, young or old, who picked up a pencil and paper one day and decided to draw a dragon.

Acknowledgments:

I'd like to thank everyone at Ulysses Press for making this book happen. If it weren't for them, it would still only be an idea on my "things I'd like to do someday" list! I'd also like to thank my mom, for passing her wonderful art talent on to me by teaching me how to draw and paint when I was a little girl. Finally, I'd like to thank my family for all their love and support.

Contents

Introduction

Ah, the dragon…. What an amazing creature this is, one that has sparked the human imagination for thousands of years! Whether we think of dragons as fierce, fire-breathing monsters, or as kind, wise sages, there's no questioning the power they display and the awe that they evoke in us. In their many varieties, dragons speak to us of strength and beauty—no wonder they're the subject of many talented artists.

One of the best things about drawing dragons is that there are no absolute rules on what exactly a dragon looks like. No one will say to you, "Hey, I saw a green dragon in the mall just last week, and it didn't look like your drawing at all!"

There are, however, some guidelines to follow, and that's where this book can point you in the right direction. Throughout the years I've received many e-mails from people looking for some instructions and tips on drawing dragons, so I hope this book will help both them and you.

The key to drawing these amazing beasts is not to lose patience, and to never give up. If your dragon doesn't turn out perfectly the first time, don't worry—it won't jump off the page and eat you! Just keep trying, review my examples again, and eventually you'll be happy with what you see.

In the meantime, I hope this book offers you some insight on how to draw these magnificent creatures by teaching you some basic guidelines. I've created plenty of easy, step-by-step tutorials that you can follow, and before you know it you'll be an expert dragon artist!

Section 1

UNDERSTANDING THE DRAWING BASICS

Drawing is a great hobby, because it's easy to pick up a pencil and piece of paper just about anywhere. It's no problem to stick a pencil and a small sketchpad in your pocket or backpack, and other materials can be wonderfully cheap and easy to find. Even the basics of drawing can be learned quickly, with only a little practice! If you have a bit more money to spend, you can buy really nice artist-quality pencils and paper, and probably even have some cash left in your wallet. So give yourself a pat on the back for choosing such a smart, affordable, and pleasurable pastime!

Of course, there are certain basic materials you *do* need, as well as several drawing techniques that are helpful to know before you start. In this section we'll take a quick look at these. Once you've gotten the idea of them down (such as how to shade your drawings), you can practice these techniques as you go through the book and create your amazing dragon masterpieces!

TOOLS FOR THE DRAGON ARTIST

So, are you ready to start drawing dragons? Before you begin, you'll need to gather some simple tools and materials.

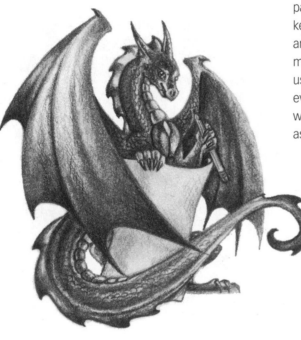

Paper

Oh, I've done so many drawings on loose-leaf paper, much to my dismay! If you like to doodle, keep a small sketchbook with you at all times, and make sure the paper's acid free so your masterpieces won't yellow over time. I prefer to use heavier-weight papers myself, and sometimes even acid-free artist Bristol board. Experiment with different papers until you find one you like, as they'll make a big difference to your drawings.

SHADING CLEANLY

To avoid messing up your drawing, shade from left to right (assuming you're right-handed; if you draw with your left hand, shade from right to left). This way, your hand won't pass over the completed sections of the drawing as much. For the same reason, it's also a good idea to shade from top to bottom.

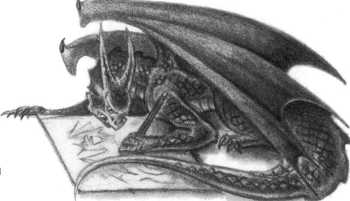

Pencils

While really cheap pencils often don't give you good results, that doesn't mean you need to spend a fortune on pencils. Pick up a few artist pencils for starters, such as 2F, F, HB, B, 2B, and 4B. The higher the F value, the harder the pencil, and the higher the B value the softer the pencil. (HB pencils are smack dab in the middle.) Try using an F or a B for your beginning sketches, but don't press too hard, so that your lines can be erased easily. The 2B and 4B are great for getting darker shades later on.

Erasers

I like to use white erasers or white eraser sticks. One more thing: Before you erase anything, make sure your eraser is clean. Test it on a scrap piece of paper first.

Blending Stumps

Also called tortillions, these are rolled-up sticks of paper with pointy ends, and are really useful when you're finishing up the shading of your drawing. They let you easily soften your pencil lines, and they're terrific for touching up backgrounds and clouds.

Charcoal Pencils

I seldom use charcoal. You don't actually need these, though they can be useful when trying to get a truly black shadow.

MAKE A BLENDING STUMP

You can devise your own blending stump by tightly rolling some soft, fibrous paper; taping it in the middle; then sanding down both ends a little. It's used to avoid transferring oil from your fingers to the drawing paper. Hold it at an angle, and keep the tips clean. For a finer point, cut a triangle out of one corner of the paper before rolling it. (You can also make a stump out of leather or felt.)

SHADING TECHNIQUES

I suggest that you experiment with several different methods to shade your drawing, once you've finished the initial sketch.

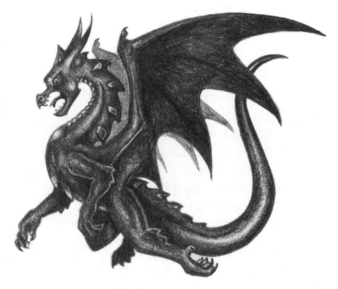

Regular Pencil Strokes and Scribbles

With this method, you simply use the pressure of your pencil to create darker and lighter areas. The lighter you press your pencil, the lighter the area will look. The pencil lines are blended together, and you don't have to pay much attention to what direction the strokes are going in. When shading in this method, harder pencils (such as a 2F) will give you more-prominent pencil lines and your shaded areas won't be as dark.

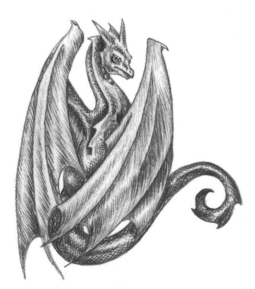

Hatching and Crosshatching

Rather than using pressure on your pencil to create light areas and dark areas in your drawing, with this method you use lines to create the effect. For example, you can use darker, thicker lines to create your shadows, where the lighter areas will have the lines farther apart and usually thinner and lighter. The only real difference between hatching and crosshatching is that hatching uses lines all going in the same direction, while in crosshatching the lines go in opposite directions, creating a grid. In the example here, the dragon is shaded using crosshatching, though her wings are shaded using hatching.

Stippling

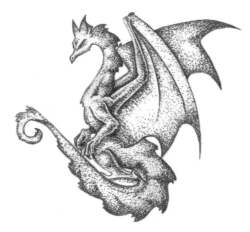

This shading technique will have you seeing dots—literally! Pens are usually the best tool to use in this technique, to make things really look right, though pencils will work as well. Simply apply more dots in the darker areas, fewer in the lighter areas. This method of shading takes a lot of patience, but can also be fun and creates a very interesting piece in the end.

Smudging

All you need for this technique is your finger, though blending stumps work a bit better (and will also keep your fingertips from getting black). I find that smudging works really well after you've done your shading using regular pencil strokes. It softens lines easily and lets you get some nice light, softer tones without having to use a harder pencil. You'll probably find, after your smudging is complete, that you need to shade a little more with your pencil, to darken up your shadows again. I typically smudge when drawing clouds and backgrounds.

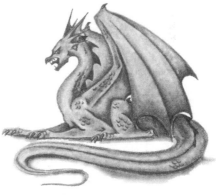

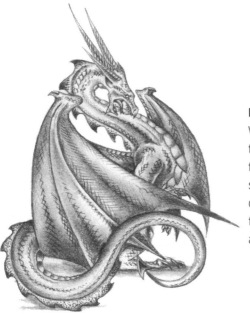

Mixed Methods

When all's said and done, there's no need to stick to only one shading method. I myself use stippling the least, but will often combine regular pencil strokes, crosshatching, and smudging all in one drawing. Give each one a try yourself. I'm sure in no time you'll find the method that works best for you as you bring your scary or friendly dragons to life.

PERSPECTIVE

The concept of perspective will come more into play when you're placing a dragon in a scene with other dragons or background content. The basic idea is that when objects get farther away, they look smaller and tend to fade in color, contrast, and detail. Plus, they'll move farther up on the horizon line. The following illustration covers a number of different points.

Overlapping

The dragon is overlapping the trees, so naturally we assume that the trees are behind him, and thus farther away. If the trees weren't overlapping the dragon at all, but rather were just beside him, then we might think the trees were right beside him and therefore small. Plus, the image wouldn't look as natural.

Horizon Line

As the objects in the background get farther away, they are moving *up* the paper toward the horizon line. This concept is called single-point perspective, meaning there's one point at which the horizon disappears. In this drawing, the hills move *up* the paper, which makes them look farther away.

Atmospheric Fading

As your objects get farther away, they start to fade. They're lighter in appearance and will have much less contrast—that is, they'll start to look all one tone—and they'll also have much less detail. Check out two examples of this type of fading in our drawing here. First, the hills in the background get lighter and you can see less detail in the forest trees the farther away they get. Second, the dragon flying in the background is very light in tone, with little detail. If it had too much detail or was too dark in color, it would look like a tiny little fairy dragon flying beside the big one.

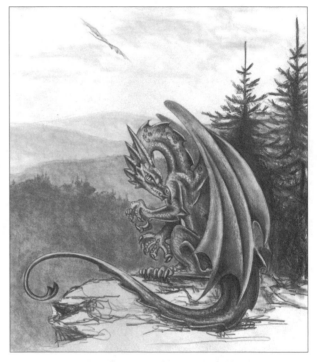

TAKE CARE WITH LIGHTING

It's important that you choose a direction for your light to come from. Softer shadows and lighting are good to use when portraying a calm scene, such as that even light that's cast by a foggy day. Harsher shadows will create a more dramatic look, such as the light thrown over the land from the setting sun or the glow from a street lamp. Practice drawing shadows using simple objects around your home.

FINISHING TOUCHES

I've seen people become discouraged and give up on their drawing because it isn't turning out perfectly the first time. Don't do this! (It makes dragons crazy—they don't like being given up on when you're drawing them.) There's no reason to discard an entire drawing simply because one part isn't working out. If you're totally stuck on one part of the dragon, put it aside for a while. I think the longest time I put drawings down before finishing them was about eight years. Seriously! Plus, sometimes you can "hide" those annoying body parts that you're having a little trouble with, by making a wing a bit longer, or adding some small bushes, grass,or boulders in the foreground. It's better than giving up on the drawing altogether.

Also, once you've done the initial sketch, either you can carefully erase your sketch lines, or you can trace them onto a new, fresh piece of paper. Personally, I prefer the second method, because I like to keep all my initial sketches, as a sort of proof that I did come up with the drawing idea. It also gives me a chance to make a few last-minute changes if need be, such as drawing the body a little longer or neck a little shorter. It also feels good to do the final drawing on a clean piece of paper.

Now that we've covered the basics, you're ready to start drawing. So go get your pencils, an eraser, and a nice big piece of paper. But before you start drawing, here's one last pointer: Use the entire piece of paper for your drawing. It's always good to start your drawings large, so you can add lots of detail. Too many times I've seen people take a drawing book with small drawings in them, then try to follow a tutorial by drawing tiny little circles the same size as the ones they see on the page. Draw large! Follow the examples I've provided, but try drawing them much bigger than they are in this book (where they're reduced, to get them all in). Many illustrations you see in books, magazines, and comics are drawn large and then shrunk down digitally to fit on the page, thus making all the details much easier to draw.

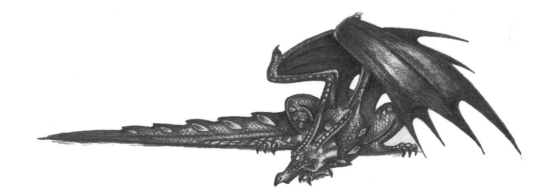

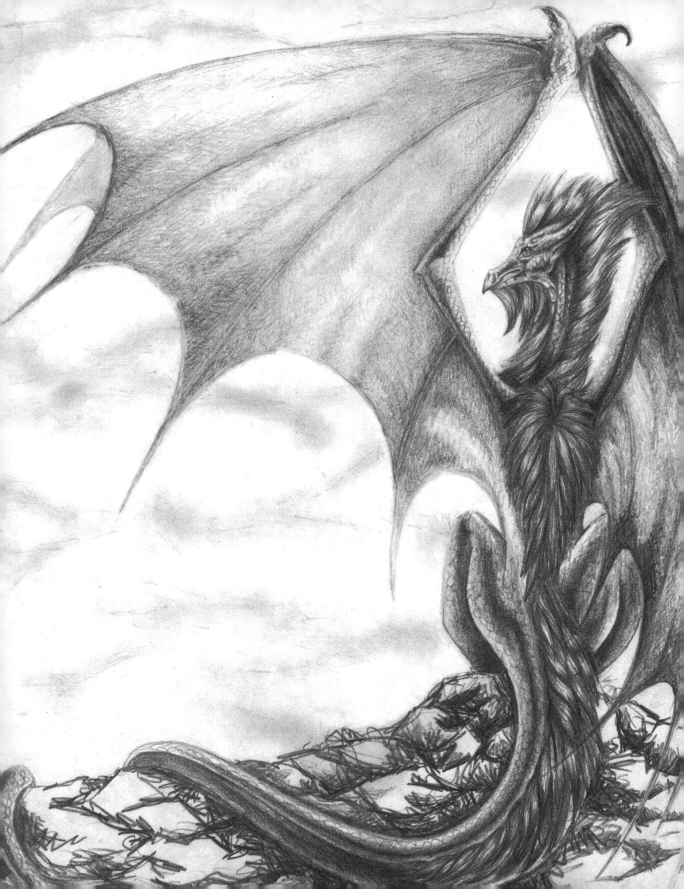

Section 2

DRAWING THE DRAGON FORM

Like most creatures, dragons can come in many shapes and sizes. How you draw your dragons may depend on a lot of things, like what environment you imagine them in (a sleek, icy-looking dragon wouldn't make sense in a tropical rainforest), and what personality or purpose you want them to have (for example, a fierce hunter is likely to be strong and muscular).

It's also up to you to decide how much personality you want to give your dragons. The more generic and unemotional your dragon, the more animalized and unintelligent it will look. In the same way, if you give your dragon more-expressive facial features and eyes, he will spring to life with his own personality. You can also give him more character by endowing him with a unique body shape (for example, an old, grandfatherly dragon may have large, droopy ears and a potbelly).

You may want to consider whether you want your dragon to be kind and benevolent, fierce and strong, or downright evil. Smoother curves, sleek bodies with fewer horns, and softer shadows all help create a more gentle-looking dragon. Having fewer teeth showing and large, kindly eyes (by drawing a round pupil instead of a slit) will also help make him look friendlier.

By contrast, evil dragons will usually have more horns, talons, and spikes, plus plenty of sharp teeth showing. Drawing their scales with a rougher appearance and their body shapes more muscular and compact also helps lend character to this look, along with snakelike eyes and a heavy brow. Appearances can be deceiving, however, so be sure to mix things up a bit!

DRAGON EYES

A dragon's eyes aren't something you want to find yourself gazing into—especially when he starts getting a hungry look on his face! So it's important to make sure you know the basics of drawing the eyes, in case you have to flee quickly from your hungry model and finish your drawing up later.

1 Start with a basic eye shape. It's like an oval, only pointy on both ends.

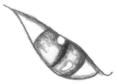

2 Place the circle in the eye for the iris, deciding at this step how large you want the circle to be. A fully visible circle will make the eye look wide open, but a partially visible one will make the eye look narrowed or partially closed.

3 Decide what type of pupil you want your eye to have. The example shows a narrow slit. Add a small circle for the highlight in the eye. Where you add it will depend on which direction your dragon's light source is coming from.

4 Begin shading the eye. The more highlights (white areas) you have on the eye, the shinier it will look.

5 Finish your shading and admire your work! Add an upper and a lower eyelid, as well.

MANY KINDS OF DRAGON EYES

The type of eye you draw for your dragon will greatly affect the beast's personality. Here are some basic types to consider.

Narrow, Lizardlike Slit

This type of eye is very cold and impersonal. It's great for creating fierce, angry-looking monsters and evil beasts.

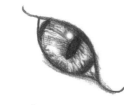

Catlike Slit

These pupils are also slits but are wider, and they don't span the entire eye. They're much warmer, cunning-looking eyes, and often have a darker area around the outside of the iris.

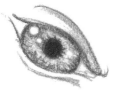

Small Round Pupil

This is a very human-looking eye, which makes it easier for people to relate to your dragon. It's a great eye to use when drawing caring, kind dragons.

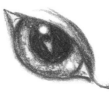

Large Round Pupil

These eyes are perfect for great, gentle beasts. They help create a lazier, more laidback-looking dragon, and are well-suited for dragons with fur instead of scales.

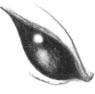

Solid Black Eye

For a truly otherworldly look, draw a shiny, solid-black eye.

Undead White Eye

Ahhh, run for your life! It's not a dragon…it's not a zombie…it's a *zombie dragon!* What could be scarier than a dragon you can't kill because it's already dead?

FACIAL EXPRESSIONS

You can give your dragon one of four basic looks—happy, sad, angry, or unemotional. From there, you can mix things up a bit to create different looks (such as a happy/angry combo, to create a truly sinister dragon).

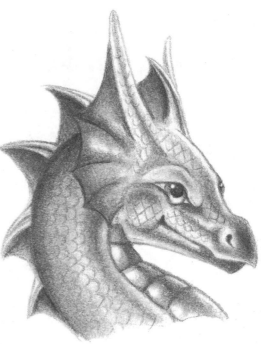

Happy

On a happy dragon, the lips turn upward, then end in a smile. The cheeks are round and cheerful-looking, creating an upward curve under the eye. The dragon's eyes must be wide open and alert-looking, and his ears will be perked up. His eye ridge will also be raised and curved upward toward the back.

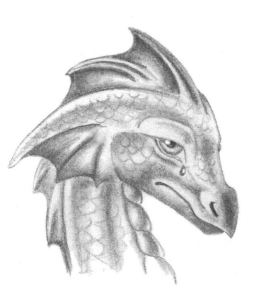

Sad

This dragon's mouth is down-turned and his cheeks are no longer puffy. His eyelid droops and his brow is straight and flat. His ears also droop. If you want, you can add a few tears to the poor fellow.

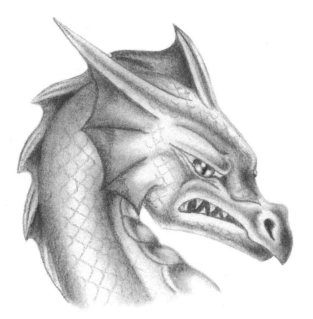

Angry

This dragon's mouth is slightly open, showing his razor-sharp teeth. His nostrils are flared, lips are raised in a sneer, and eyes are narrowed. His eyebrow comes down, closer to his eye in the front than the back. His ears go straight back and his neck arches and spines rise (like an animal's hackles rising—or your cat's on Halloween!).

Unemotional

This expression is common for dragons resting or sleeping. All their features look relaxed. The mouth is straight and the cheeks and eyebrows are smooth.

DRAWING THE MOUTH OPEN: TEETH AND TONGUES

To make your dragon's emotion look stronger, draw an open mouth instead of a closed one. How much of the teeth you show has a powerful effect on how it looks. The type of tongue can also affect mood.

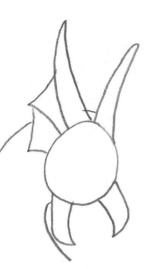

A Happy Dragon
When drawing a happy dragon with his mouth open, have the mouth curve upward in a smile. Make sure his eyes are wide open and not angry-looking. You can see that this fellow's teeth aren't bared, and his round tongue is friendly-looking and not overly extended.

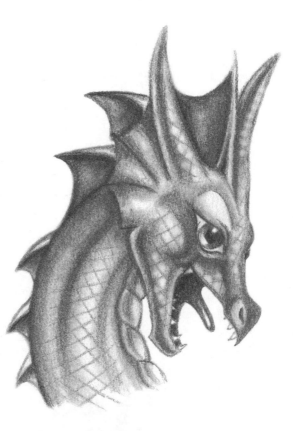

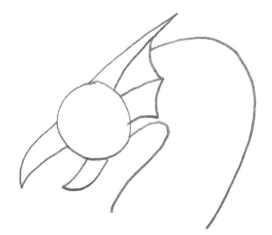

An Angry Dragon

This dragon has no smile on his face, and his eyes are narrowed into angry slits. His teeth are bared, and his lips are pulled back to fully expose them. His tongue flicks angrily at you, and, as you can see, the split tongue also looks less friendly than the small round one.

VARIOUS TYPES OF DRAGON EARS

A dragon's ears can also affect how you portray his emotions, and will certainly affect the mood your drawing conveys. Let's take a look at a few ear variations.

Pointy Ears

These ears are common on dragons, and change position depending on the dragon's mood. They'll perk up when the dragon is listening and attentive, and lie low on his head when the dragon's angry or out hunting prey.

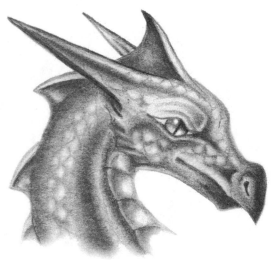

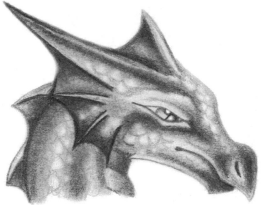

Fan Ears

These ears are similar to pointy ears, except they fan out at the bottom. Such ears are great for picking up every little sound. This fellow doesn't seem too happy with the change, though! (I guess he prefers his normal pointy ears.)

Small Round Ears

Round ears look great on female dragons, or when drawing a kind, compassionate dragon. They're also common on Oriental dragons. Our dragon friend here seems to be startled by these ears. Maybe he thinks they're too gentle-looking. But, trust me, some dragons would be proud to have this type of ear.

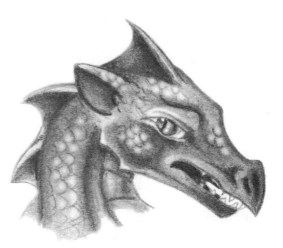

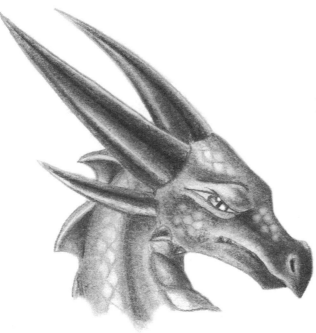

No Ears

Some dragons have no ears at all—at least, that you can see. Their ears are simply tiny holes (as in reptiles). You'll find this frequently on dragons that sport massive horns on their heads. They simply don't have room for ears too! Such dragons are fierce-looking creatures. Speaking of which, we'd better stop changing this dragon's ears, as he's starting to look angry and might eat us!

THE FIRST STEP: DRAWING THE ENTIRE HEAD

Now that we've looked at the various parts of a basic dragon's head, we can begin drawing a whole one. Dragon heads come in many forms, depending on the type of dragon you're drawing. (See Section 5 for some unique types that will get your imagination soaring!) A slender *sea serpent* would have a flatter forehead but no ears, while a *baby dragon* would have a short head and a face with large eyes.

I always start my dragon drawings with the head. It's the most important feature, because it will really set the dragon's personality. It's also important because how you draw the neck will affect the dragon's entire position and body type. A thick, short neck wouldn't look right on a sleek, slender dragon, nor would a long, sinewy neck look like it belongs on a muscular, stocky hunter. Also, straighter lines for the neck will make the neck look more stretched-out.

After you've completed the following tutorials, practice various dragon head poses by starting with the basic circles and shapes. And don't fuss with making your circles perfect—as long as they're close to being round, they'll work fine. (You're going to erase them anyway, or eliminate them when you retrace your sketch.) Also, take care not to make these circles and basic shapes too dark or to press too hard with your pencil, as you'll have to erase these lines later. I recommend using an HB pencil or even an F pencil, which won't stain your paper so easily.

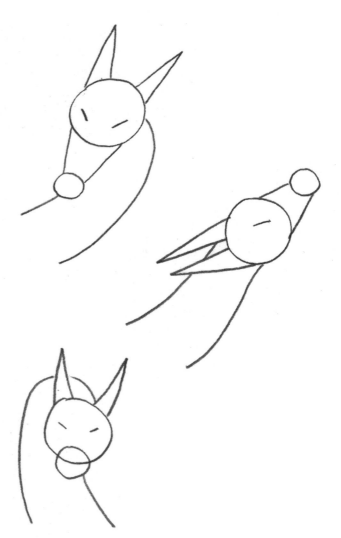

THE HEAD: SIDE PROFILE

Let's start by drawing the dragon head from the side. This is one of the most common and easiest positions to draw.

1 Start by drawing two circles—a large one for the main part of the skull, and a smaller one (about 1/4 the size of the larger circle) for the snout. There should be a space between the two circles that's about as wide as the smaller circle's radius. Connect the two circles with straight lines. This basic structure will be the start of the skull and jaw.

Note that this will determine the overall shape and length of your dragon's face. So, if you want a cute dragon, draw the two circles closer together to make the dragon's head short.

2 Next, start your ears by adding two triangles to the head. The bigger the ears you want, the bigger the triangles. Then decide how you want the neck positioned, using smooth curvy lines. (Straighter lines for the neck will make the dragon's neck look more stretched-out.) The neck should connect to the main circle, and should normally be about as thick as that circle, to give your dragon a good, strong look. (If, however, you're drawing a more elegant or fragile dragon like a *fairy dragon*, you can make the neck a bit thinner.)

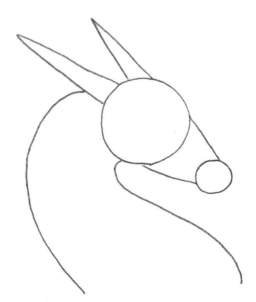

3 Now rough in your basic features over the circles. Start by adding a pointy eyebrow ridge, plus a point for the nose. The end of a dragon's nose should be beaklike (think "eagle beak") but with a point jutting up right above the nostrils. If you draw these features too soft and smooth, your dragon may end up looking more like a prehistoric bird! Draw a line about two thirds of the way down the face for the mouth, then position the eye. The eye should fall near the center of the main circle.

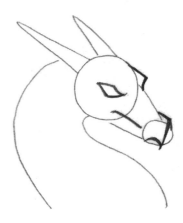

4 Start filling in some more details and connect the main lines of the face. Rough out any added details you want, such as horns, frills, or spines.

5 This is the final step before you either erase all the lines or copy your dragon onto a fresh sheet of paper. Figure out the basic layout for your scales as well as any other small details you may want to add.

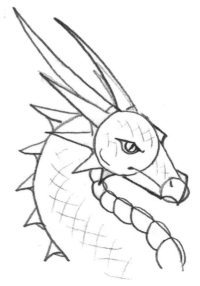

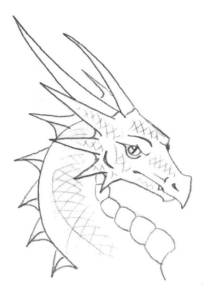

6 Now's the time to clean up your image and prepare it for shading. You can do this either by erasing the lines and circles you no longer need, or (if your sketch is very rough) by tracing it onto a new, clean piece of paper. I usually like to make a tracing so I can file away my original rough sketch for possible future use.

7 At last your dragon's ready to shade! Begin by choosing an angle for your light source. Don't start too dark, because this is your chance to make sure that the lighting looks right. Use this step to decide where you want your highlights to go, as well, by leaving those areas white.

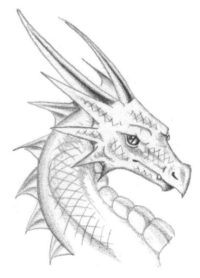

8 Now you're ready to finish your shading, so choose your pencils carefully. Softer lead pencils will give you darker shades and more visible stroke marks, and will easily smudge your paper. You might try starting out with a harder lead, like an HB or an F pencil. You can always use a softer pencil later on to fill out the too-dark areas.

THE HEAD: FRONT PROFILE

Drawing the head from the front view is similar to drawing the side view, though now you need to work on making the dragon's face symmetrical. It doesn't have to be a perfect mirror on each side (if you consider the nose as the dividing line). Keep in mind that, in nature, even our own faces aren't exactly the same on both sides, though they're darn close!

1 Once again, start the head with two circles. The farther away the circles are, the narrower the dragon's head will look, and it will appear as if the dragon is lowering her head more. (If you want to draw the dragon's head to show she is snootily looking down her nose at you, overlap the circles slightly.)

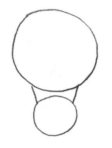

2 Position your dragon's ears, and decide how you want the neck to attach to the head.

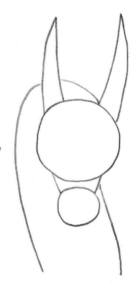

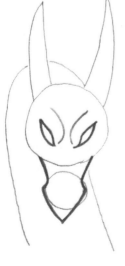

3 Draw the nose. Again, it will look similar to a sharp eagle's beak, but with ridges above the nostrils. The eyes should be closer to the edge of the larger circle, but not too far apart. Remember, your dragon is a fierce and intelligent predator, and you'll portray this best by giving her binocular vision (just like we mere humans have).

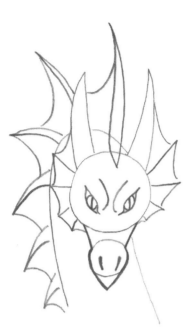

4 Next, fill out the details you want, by way of fins, spines, and nostrils. Also complete your dragon's eyes in this step.

5 This is your last step before creating the final sketch for shading. Use this to decide what type of scales you want and any other finishing details.

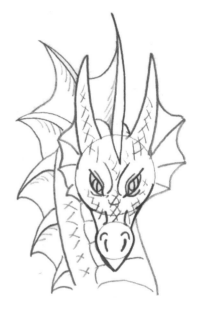

CAN YOU SEE ME NOW?

Nearly all animals have two eyes. This "binocular vision" gives them a wider field of view, and also a spare eye in case one's damaged (by jousting with an evil dragon). Plus, it allows for better depth perception, which is vital to dragons when hunting. The eyes of predatory animals like wolves and tigers usually are positioned facing forward.

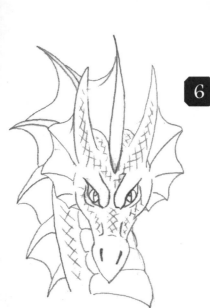

6 Erase your building lines, or trace your dragon onto a new piece of paper.

7 Now begin your shading. Also, decide what angle you want your light source to be coming from.

8 Finally, finish shading your dragon. Using a blending stump (see tip on page 3) will help soften your lines and give your dragon's scales a smooth, supple look as if she had just finished buffing them in front of the mirror (dragons can be so vain!).

THE HEAD FROM DIFFERENT ANGLES

Now that you've drawn the head from the side *and* the front, you've learned all the basics you need to know. Way to go! Drawing the head from any other angle is pretty much the same. Always start with your two circles and work up from there. The main thing that really changes your dragon's perspective is placement of the eyes.

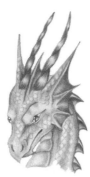

Partial Side View

When drawing the dragon's head at a partial side view, you'll be able to see either part of the other eye and nostril, or at least the other eyebrow and nostril ridge. Both ears and both horns will also be visible.

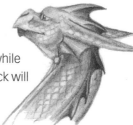

Partial Bottom View

From this angle you'll see only one eye and a nostril, which will be near the top of the visible part of the head.

Partial Top View

Again, from this view you may be able to see part of the dragon's second eye and other nostril, depending on how far the head is tilted.

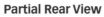

Partial Rear View

You'll be able to see only one eye here, while more of the back of the head and the neck will be visible.

Straight-on Front View

From this angle you'll be looking down the dragon's snout directly into his eyes. This is an unusual view, as it makes your dragon more comical-looking than fierce, and you'll be nose-to-nose with a very large snout.

TYPES OF DRAGON HEADS

Dragon heads and faces can come in many shapes and sizes—from a slender, sleek-faced flier, or a blocky, strong-looking hunter, to a round-faced, cute baby dragon. Although the fundamentals of drawing the head are about the same for each, you should be aware of a few differences.

Broad and Blocky

These dragons have thick skulls and necks and are terrific at destroying entire castles. The point where their neck comes up and meets their head is as thick as their head, and their necks tend to be stiffer, shorter, and straighter. Their heads are square and they usually have shorter, flatter faces and noses.

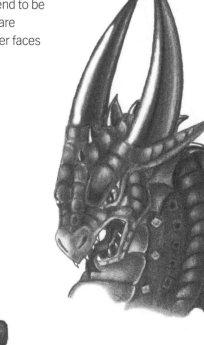

Long and Lean

Are these dragons elegant or sinister? That's up to you to decide! These dragons can certainly have a sinister, snaky look to them, with their long, curvy necks and thin faces, but they can also be swift fliers or runners, and could even have gentle, kind personalities. When drawing these dragons, make sure their necks are thin and curvy, while still looking strong enough to support the heads.

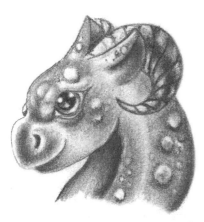

Round and Squat

This facial structure is most common in baby or immature dragons, but is also a great way to draw cute ones that look harmless…until they eat the pencil right out of your hand!

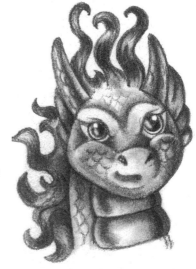

DRAWING THE BASIC DRAGON FORM

Although there are many different types of dragons and a multitude of ways you can draw them, certain characteristics are typical for these creatures—such as having large, batlike wings; powerful legs and claws; and long, dangerous tails. Let's look at what's involved in drawing these "dragon basics."

You can draw many kinds of limbs on your dragon creations, so the trick is to decide which type you want for each one. The type of limbs you choose (and how many of them) will greatly influence both the look of your dragon and his abilities to wreak enchantment or destruction.

Typically, dragons have large wings; smaller front legs and claws that can also act as arms and hands; and large, strong hind legs and claws for standing on and catching big prey. However, these are by no means the only options you have. Let's look at some of the limb types you can draw, and then you can think about which ones you like the best.

Four-Legged, Two-Winged Dragon
This dragon is adept both on the ground and in the air. Her wings are large enough to support her in flight, her hind legs strong enough that she can stand on them or sit back on them when she wants to, and her forelegs powerful and well-suited for grabbing knights off horses (or entire horses, for that matter!), almost like arms when need be.

Two-Legged, Two-Winged Dragon

This dragon has no forelegs and has a more birdlike anatomy. His hind legs are extremely strong but can also be long and elegant. Sometimes this type of dragon has a handlike part on each wing that he can use, but typically he uses his legs for grabbing stuff, much as a bird would.

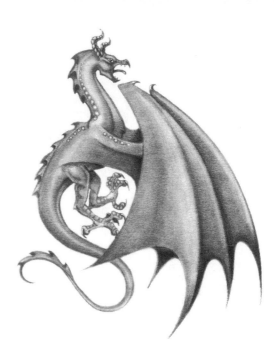

Flightless Dragon

This type may have tiny wings, or none at all. Some walk on all four legs and are quite animal-like, resembling a huge lizard, while others may walk on two enormous hind legs, in the manner of a tyrannosaurus rex dinosaur. You choose your style and work from there.

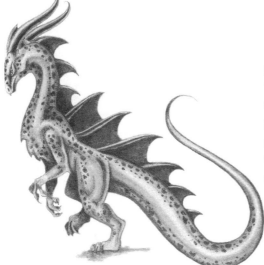

Fanciful Dragon

Of course, since *you're* the artist wielding the pencils, you can give your dragon multiple wings or limbs, such as in this precious little *dragonfly*. Two things to keep in mind: have fun, and find a style that suits you best.

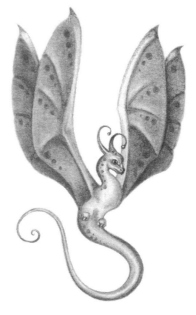

THE HIND LEGS

Dragon hind legs are usually pretty much the same structure from one dragon to another, though they can be very different looking, depending on how thick or lean they are.

Thick hind legs will make your dragon look heavy and powerful, whereas thin, long hind legs will make it appear quick and agile. Let's take a look at some of the basic types of hind legs you can draw on your dragon to use for locomotion as it goes out plundering or adventuring.

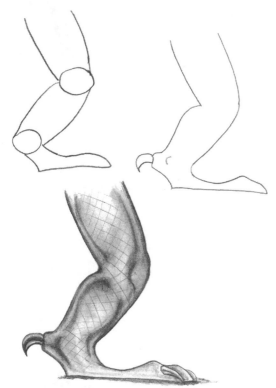

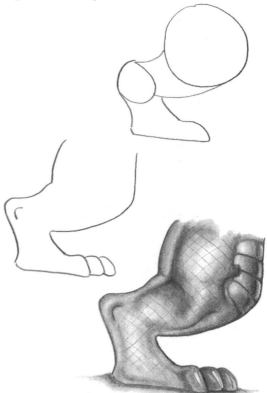

Regular Dragonish Hind Legs

These hind legs are typical for a dragon. They're good for walking on, grabbing things, crouching, and simply standing on (without using the forelegs) when need be. The knee bends forward, and the thigh's about the same size as the shin.

When starting these legs, make both circles for the knee and ankle the same size. Connect the circles together, and to the hip, to form the rest of the leg.

Animal-Like Hind Legs

These legs are more common on large, muscular dragons. The thigh is huge and the shin (foreleg) is smaller, with a prominent calf muscle.

These legs can be started using a large circle to begin the thigh and knee, with a much smaller circle for the ankle. Notice that the ankle is higher and farther back on these legs than on the regular dragon legs.

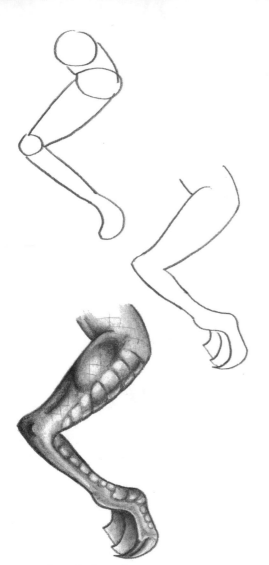

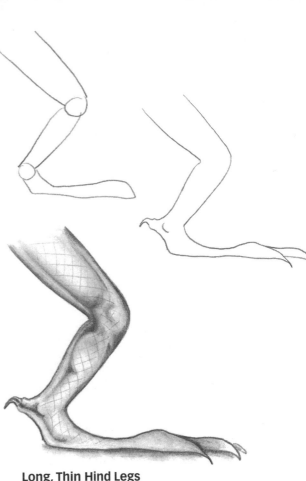

Birdlike Hind Legs

This type of leg is great for dragons that have no arms and therefore require strong, versatile back legs. Notice how there's virtually no thigh muscle at all, and the leg is mostly composed of the shin and what's really just an elongated foot with long toes on the end.

When drawing the basic layout for these legs, keep in mind that they appear to bend backward compared to normal legs, because of the tiny thigh (or lack of one). It may be helpful to draw three circles instead of two; draw one to represent the part of the leg that would normally be the thigh, then one for the knee and another for the ankle.

Long, Thin Hind Legs

These legs are quite similar to regular dragon legs, only they're long and skinny, making everything look somewhat stretched out (even the feet and claws). They're great for quick-running and agile-looking beasts.

When you start these legs, spread everything farther apart. Although the drawing technique is similar to that for the first set of legs, when drawing your basic layout you should leave far more space between your circles.

THE FORELIMBS

Just as there are a variety of hind legs you can give your dragon, there are a similar variety of forelimbs you can draw. Let's take a look at them now.

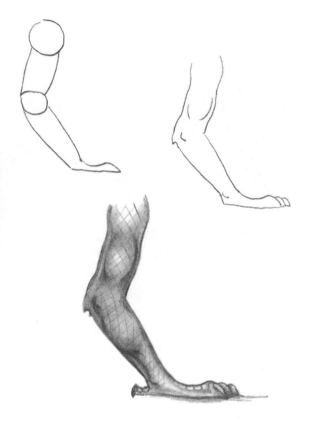

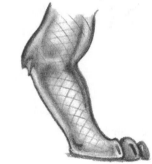

Regular Dragon Forelimbs

These forelimbs are quite armlike, giving the dragon the ability to pick things up with them. But they're also long and strong enough that they can act as front legs. This doesn't mean they have to be thick and chunky—only that they can reach the ground and act as legs when the dragon's out walking around.

When starting these legs, draw the top circle where the arm attaches to the shoulder, and a second circle for the elbow.

Animal-like Forelimbs

For a thicker, stockier look, you can give your dragon strong, animal-like forelegs. These legs won't have as large a bicep area, but *will* have a large, muscular forearm. The paws will also be larger and less suited for picking up objects.

When beginning your basic layout for these limbs, draw the shoulder and elbow circles closer together.

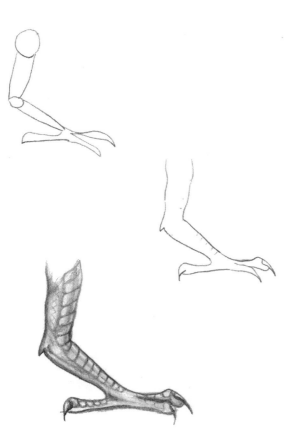

Birdlike Forelimbs

These dragons have elongated, elegant forelimbs that end in long, talonlike "hands." These talons are also good for picking up objects, but in a less-versatile way than actual hands could.

When drawing these forelegs, be aware that they tend to have less muscle definition, so make the connecting lines between your circles quite straight.

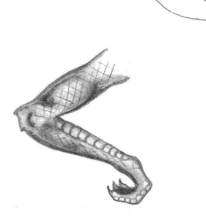

Small, Nonwalking Forearms

This type of forelimb is common on the dragon variety that walks on only two hind legs. His arms will be much smaller in comparison to the hind legs, and usually won't contain any massive muscles.

When drawing these forelimbs, make the circles for the shoulder and the elbow small and far apart, so that the arms will be skinny once the circles get connected.

CLAWS AND FEET

You can draw a dragon's claws and feet in many interesting styles, adding to their personality (and their threat, or charm). You can also pose them in many ways—we'll cover the most typical.

Let's begin by looking at the hind feet. These tend to be simpler than the front claws, with less variety for positions.

THE HIND CLAWS

You may be surprised at how the type of hind leg you draw will affect the type of claw you can give your dragon. If you've drawn birdlike feet, they most likely will look the best with birdlike talons. There's no golden rule for this, however—which is one of the wonderful things about drawing dragons! Let's look at several options you have for giving your dragon really cool-looking feet.

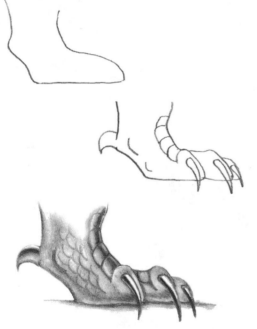

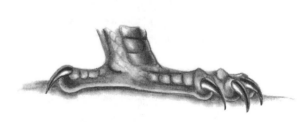

Animal-like Hind Feet

These are great feet for dragons—strong and sturdy-looking, with talons that look like danger itself. These feet tend to have shorter toes, and the "big toe" is actually more of a hook on the back of the foot. The feet are fairly short, but still appear well-planted on the ground.

Birdlike Hind Feet

This type of foot is also common on dragons, especially those that have only hind legs (but no front legs). They're great for grasping things but still have a definite "foot" look to them, as they're set firmly on the ground and the toes flatten out nicely. Notice how the toes look much longer and the claws protrude farther than in the animal type shown.

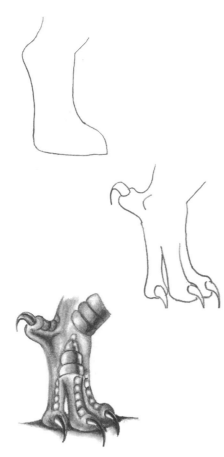

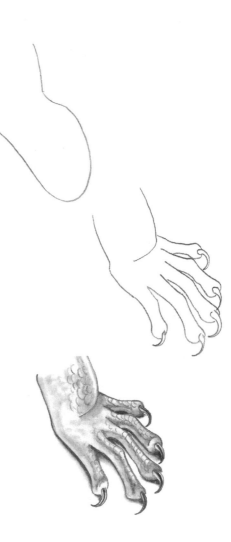

Dinosaurlike Hind Feet

These are perfect feet for quick runners and speedy hunters. They leave the dragon literally on his toes. These feet don't look firmly planted on the ground at all, but look as if they could take off running at any second. They're great for dragons that walk only on two legs and have small front arms.

Lizardlike Hind Feet

Lizard feet are often, well…funny-looking. Their toes are all different lengths and tend to sprawl all over the place. Yet these are fine feet to give a dragon that's scaling a wall or hanging off the side of a cliff, as they really do look like they could hold onto virtually anything. They're flat and broad, and the claws seem to stick right off the toe.

THE FRONT CLAWS

Wow, now we're into some really tricky stuff! You may find that, other than mastering the dragon's face, the hardest things to draw are hands and claws. So before we delve into the various types of claws, let's take a close look at drawing a basic dragon's claw, which is actually quite handlike.

DRAWING THE BASIC CLAW

It's up to you whether you want to draw your claw with three fingers or four. It depends mostly on the type of dragon you're drawing. It's more difficult to draw four fingers than three, though, so let's tackle that first. Everything else will seem easy from that point on!

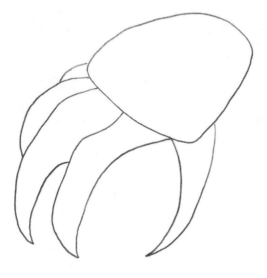

1 Determine how you want your dragon's fingers positioned. Here we start with a sort of triangle for the main part of the claw, and then add four pointy shapes for the fingers and one for the thumb. This gives you a basic layout of how the hand and fingers will be positioned.

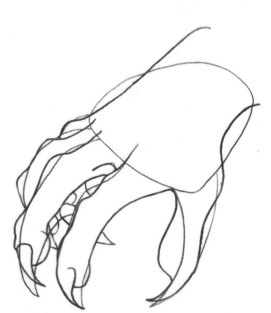

2 Round out the thumb and fingers. Take care to add bumps for the knuckles along the fingers, otherwise they'll look too rubbery. Set the nails into the top of the claw, much the way our own fingernails are set.

3 Erase your construction lines, and add scaly plates to the fingers. Because fingers are fine joints that move, they can't have regular scales, so these scales will be more rectangular and supple so that they can move with the claw and fingers.

4 Finish up your shading, then check out the great claw you've drawn! Don't forget that fingers are round, so add appropriate highlights and shadows where they need to be.

DIFFERENT CLAW POSITIONS

Now that you've mastered the basic claw, it's time to look at some other poses. Practice these as much as you need to, for they can really make a big difference in how realistic your dragon looks.

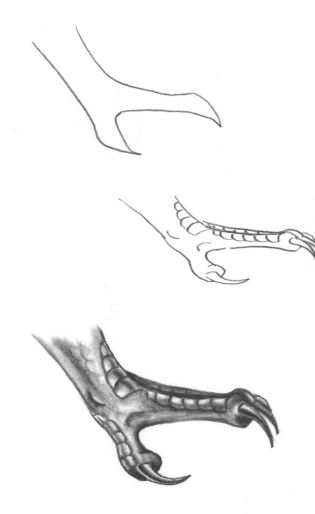

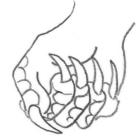

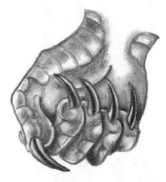

Resting on the Ground
This is a great pose for dragons depicted as standing on all four legs and that have very handlike front feet. The claw looks firmly planted on the ground, and the thumb fans out for additional support.

Closed Fist
The dragon's fist is closed into a tight ball. Start by drawing a roundish shape, then add each finger so that they're contained in that ball and not sticking out. Notice how the talons flatten out a bit against the dragon's palm (otherwise they'd dig into his skin).

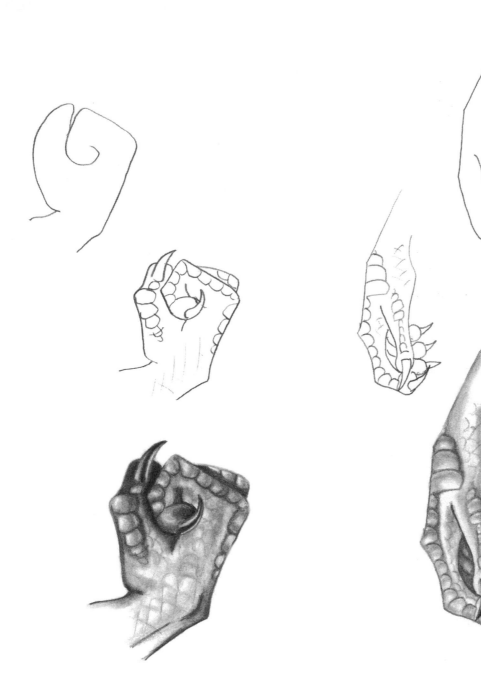

Grasping Fist

Behold the fist of power! Again, start with a circular shape with the fingers spiraling inward. The claws will curl in against the dragon's fingers.

Hanging in Resting Position

This pose is great for a dragon that's not doing anything with his front claws, such as during flight. The fingers curl naturally and appear relaxed.

DIFFERENT TYPES OF CLAWS

Now that you've perfected your technique at drawing handlike claws, let's look at a couple of other types of dragon claws that you may want to depict.

BIRDLIKE CLAWS

These talons make great front claws for dragons, so they're very common. They're still great for grabbing and holding things, but they tend not to be as versatile as a more handlike front claw. They commonly have only three fingers, though some Oriental dragons (see page 132) will have four.

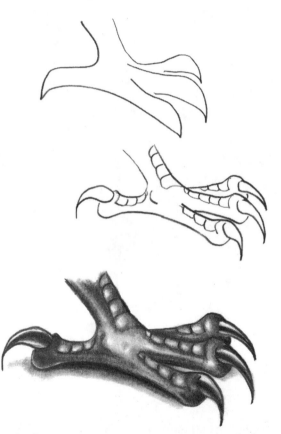

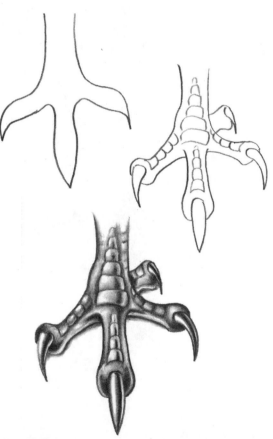

Side View
When set firmly on the ground, these claws are held at a slight angle so that all the toes are visible.

Front View
The three fingers spread out, giving the dragon fine standing support. You can draw the hind toe showing a bit to the side, or have it completely hidden by the forelimb if you prefer.

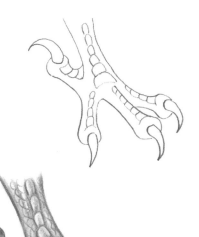

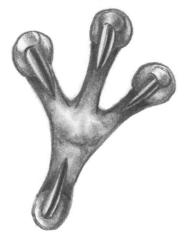

Partial Side View

This angle shows the top of the claw or hand, and is great when drawing your dragon standing on all four legs.

Outstretched

The fingers curl inward to create a dangerous grasp. This pose also works well for hind feet on dragons that have no front legs.

ANIMAL~LIKE CLAWS

These claws are the least versatile and are best on large beasts that walk on all four legs most of the time. Their short fingers don't really allow for grabbing things, so these dragons would have to grasp their prey between both claws, digging their talons in firmly.

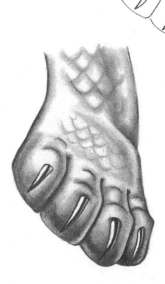

Side View

These massive paws plant firmly onto the ground. The fingers (or toes) are close together, and the talons don't protrude too far off the foot.

Resting

When in a resting position, the fingers relax and straighten out. The talons also partially recede into the toes.

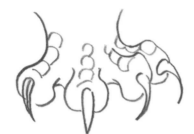

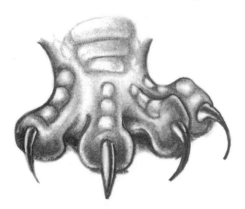

Outstretched

When the dragon is hunting, his fingers or toes spread out to create a quiet step. The talons are fully exposed—and the dragon's ready to pounce!

Raised and Flexed

The fingers are now flexed and spread out as far as they'll go, as if the dragon's trying to grab at you. It's up to you whether to put pads on the bottom of your dragon's feet. (It's common for animals to have them, so it'll look more natural if you do.)

DRAGON TAILS

Tails are all about balance. They help a dragon while walking so that she can carry herself with a graceful step…they can help a hunter slow down or turn suddenly by whipping out quickly in a new direction…and they can be used to help a dragon balance on both legs by fanning out behind her. There's not much to drawing a tail—it's simply a long appendage that attaches to the dragon at the hip and slowly tapers to a fine point. The trick lies in determining how long the tail should be.

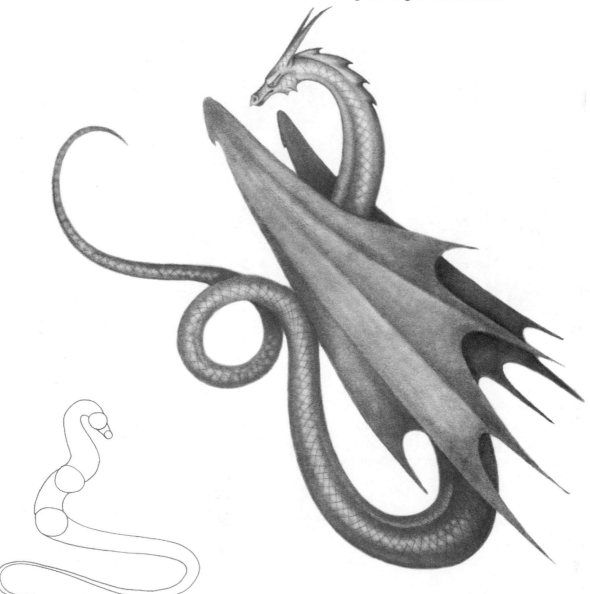

Tail Proportions

A dragon's tail should match the rest of him (or her). Dragons with long, sinewy bodies and elongated, arching necks are balanced best by having long, winding tails. Likewise, broad, short-necked dragons will have short, thick tails. Tails can also be useful tools for winding around and grabbing things, so keep that in mind as well.

Pointers for Drawing Tails

When drawing tails it's important to recall that they're huge, round muscles, so make sure you've put the appropriate highlights on them where the light hits them. You may even create a slightly sunken spot along the side to show muscle definition. Play around with your dragons' tails to find a look and style that you like, but take care that it looks *right* on the dragon you're drawing at the time.

DRAGON WINGS

Ah, dragon wings! They're almost a defining characteristic of these majestic beasts. Of course, not all dragons have wings, since some do just fine without them. But generally dragons are creatures of flight. Their wings typically are huge and batlike.

So the main question is…how *big* do you draw your wings? That depends on how well-suited you want your dragons to be for flight. Some dragons never fly, so they can have small wings that aren't emphasized much. Others have huge wings for soaring high in the sky and making grand takeoffs. How large you want your dragon's wings to be is entirely up to you, but keep in mind that the smaller they are, the less likely that your beast will fly—and the less believable it will be in the air. Take an eagle, for example. It weighs only 10 to 15 pounds but can easily have a 9-foot wing span.

When you think about just how massively huge and heavy a dragon is…well, it makes for enormously large wings. So find a balance between believability and practicality for drawing, and you'll do just fine.

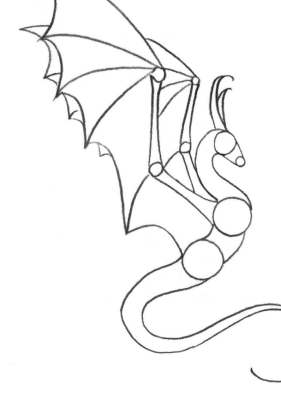

Another important aspect of drawing wings is how you attach them to your beast. Dragon wings are like an extra set of arms that attach to the shoulder. If your dragon's wings attach too low on the back and don't sit properly on the shoulder, then the dragon will look strange and anatomically wrong. Think of the arms and wings as if they both share and use the shoulder muscles, which is why these muscles should be strong and well-defined.

Dragons' wings bend like batwings, with an elbow, a thumb, and four fingers. Let's look at a few basic poses that you may find yourself drawing often.

FULLY OPEN

The main, muscled parts of dragon wings are somewhat like a second pair of arms. They should attach to the dragon's shoulder and have an "elbow," a "wrist," four "fingers," and a "thumb." When drawing your basic layout, keep in mind that they'll bend in a similar fashion to arms.

1 Start your dragon wing by drawing small circles for the elbow and wrist. Attach the circles with basic lines, then add the main finger of the wing (equivalent to an index finger).

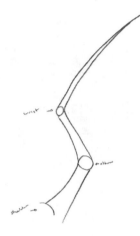

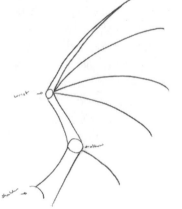

2 Add lines extending from the wrist circle for the other three fingers. There's also a supporting ridge that attaches off the elbow.

3 Now connect the fingers with smooth curves to create your dragon's webbing. Make sure that you don't curve the webbing in too far, or your dragon's wings won't be full enough to catch the air and be believable for flight.

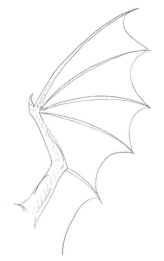

4 Now clean up your wing, erasing the construction circles. Draw a talon off the wrist (this is the wing's "thumb") and add a few lines for muscle definition. Add your scales, which should only be drawn on the "arm" part of the wing and not on the webbing.

5 Begin your shading. Determine where you want your folds in the wings to be, but don't make the wings too wrinkled or folded. Make the webbing good and stretchy so it can catch the wind easily and isn't loose like a blanket.

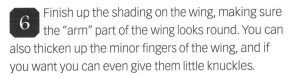

6 Finish up the shading on the wing, making sure the "arm" part of the wing looks round. You can also thicken up the minor fingers of the wing, and if you want you can even give them little knuckles.

PARTIALLY CLOSED

This is a super pose to draw wings in, as it doesn't take up nearly as much room on the paper.

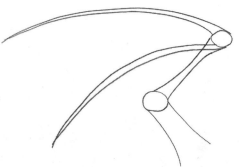

1 Again, draw circles for the elbow and wrist. Rather than just drawing the main index finger of the wing, draw both that one and another finger, to show how far open the wing is.

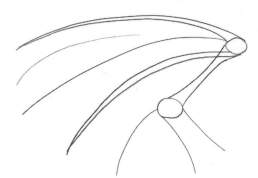

2 Add your additional fingers and elbow support. (In my drawing, I knew that one of the fingers would be mostly hidden by the wing, so I didn't bother attaching it all the way to the wrist.)

3 Now attach your webbing. See how one of the fingers is barely visible? We know it's there because we can see the tip. This creates a nice, folded-over look to your wing.

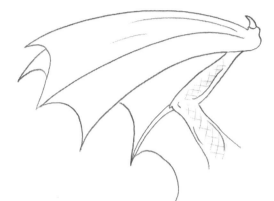

4 Erase your construction lines and add a thumb to the top of the wrist. Because this is the top of the wing now showing, we'll represent the fingers with lines only. (The main parts of the minor fingers are under the wing.)

 5 Start your shading, adding a dark shadow under the wing where it folds over.

6 You're done! Because this wing is folded over, it's not as taut, so shade in a few wrinkles and extra lines to show that the webbing is relaxed.

FOLDED DOWN

You'll find that this is a terrific wing pose for drawing lazy old dragons that are simply lying down or that appear to be resting.

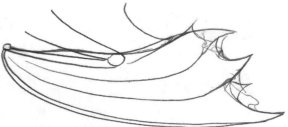

 1 The arm is folded tight into itself, and the main index finger sweeps off to the side.

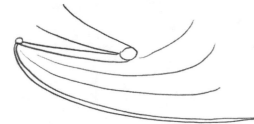

2 The minor fingers are quite close together and don't spread apart much.

3 Don't worry about using smooth, curving lines when attaching the fingers to the webbing this time, because the wings are folded so tightly that the webbing will fold and double over itself anyway.

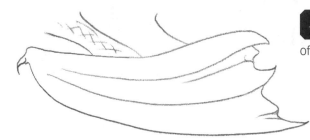

4 Clean up the construction lines and add some prominent folds to the ends of the webbing.

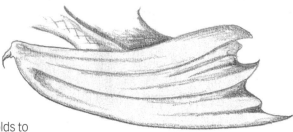

5 Add some deep shadows to the folds to make them look fully relaxed.

6 Finish up your shading. Just as the deep folds have dark shadows, the folds that curve outward should have light highlights.

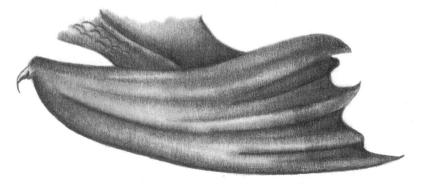

THE SECOND STEP: PUTTING IT ALL TOGETHER

Since you've already mastered drawing a dragon's head, and we've looked at the many options you have for dragon limbs, it's now time to try tackling the entire beast all at once. Let's try drawing a dragon from the side first, then another one from the front.

THE DRAGON: SIDE PROFILE

1 Start by using simple shapes to determine a general position for your dragon. In this example, we'll have him standing on all four legs. Start with a head and neck, then draw two large circles (a bit larger than the one for the head) for the chest and rump. Connect these two circles to create your dragon's belly. Finally, decide how you want the tail positioned. The tail will start wide at the end near the circle (it should be almost as wide as the circle for the rump) and then will taper off to a fine point.

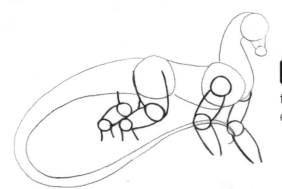

2 Add the four legs. We'll draw them so they bend in an armlike fashion. Use small circles to represent the different joints—shoulders, elbows, knees, and ankles.

BIGGER IS OFTEN BETTER

Remember, draw your dragons large—and use an entire piece of paper for your drawing. It's good practice to start your drawings rather big, enabling you to add lots of detail as you go.

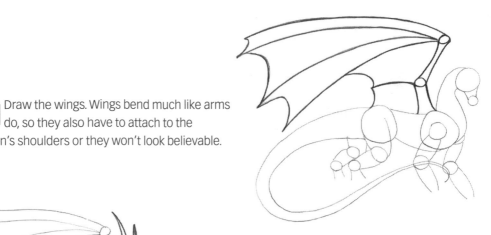

3 Draw the wings. Wings bend much like arms do, so they also have to attach to the dragon's shoulders or they won't look believable.

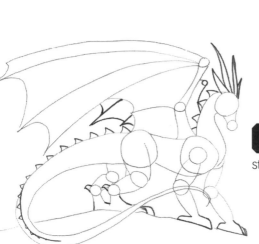

4 Sketch in the final details in basic shapes, such as ears and feet. Now we're ready to start fleshing out our dragon a bit further.

5 Start by filling out the details for your dragon's head, as you learned in an earlier section.

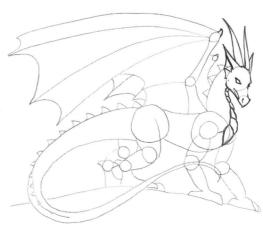

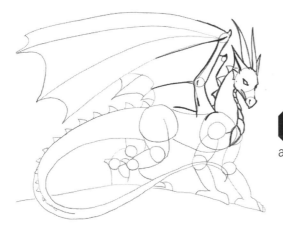

6 Now start adding more definition to your wings. Remember, they move like arms do, in a way, so they will have similar muscle tone.

7 Next, fill out your dragon's legs and arms. They have elbows and knees that have pointy bones underneath, so don't make the limbs too rubbery looking; they'll bend sharply at these joints.

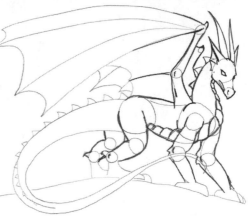

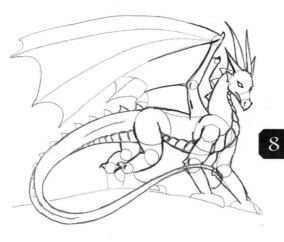

8 Flesh out the dragon's underbelly and tail, adding belly scales if you wish.

9 Finally, give your dragon feet. You can draw them in various ways, as we looked at previously, but typically they'll have large claws and handlike front feet with long fingers—all the better for grabbing princesses in!

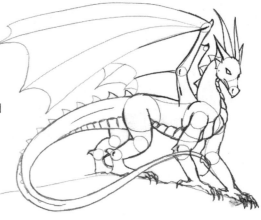

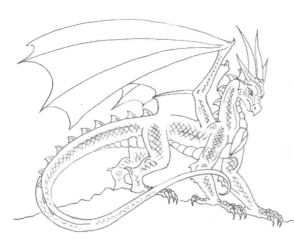

10 Add any other details you may want to work out before finishing your drawing, such as the eye and the type of scales. Then erase your construction lines, or trace your dragon onto a fresh sheet. This is a good time to erase any sketch lines that you drew too thick and to redraw them carefully, with thinner, more precise lines.

11 Begin your shading. Use fairly light tones, to determine where your light source will come from and where you want your highlights to be.

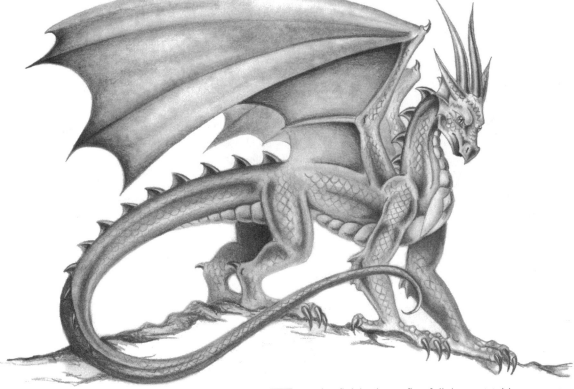

12 You've finished your first full dragon! Add a bit of ground underneath him so he has something to stand on and isn't just floating magically on your paper.

THE DRAGON: FRONT PROFILE

1 Now that you've mastered drawing a basic dragon from the side, you're ready to draw one head-on. Start with the same basic shapes: first, the two circles for the head, then the neck, body, and finally the tail. This basic form creates the foundation for your pose.

2 Now you're ready to add legs and arms. Because this dragon is sitting directly in front of you, the arms and legs will most likely mirror each other. (Unless the dragon is waving to you with one hand!) Use circles to represent shoulders, elbows, and knees.

3 Draw your wings. They, too, will most likely mirror each other, as shown here.

4 Add basic shapes for feet, hands, ears, and any spikes and fins you may want to add. Now your basic layout for your dragon's pose is complete.

5 You're ready to start working out the sketch for your dragon over the basic layout. Once again, begin with the head, then decide what type of chest and belly scales you want your dragon to have.

6 Next, start adding details to the wings. Recall that wings are like arms, in a way, so they'll have an elbow of sorts.

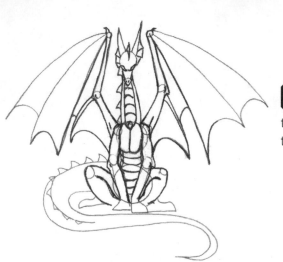

 7 Finish the arms and legs. The arms will bulge out a bit in the middle of the top section for the dragon's bicep muscles, and a bit right below the elbow for the forearm muscle.

8 Add details to the tail. It has a spine, so you'll be able to see the "top" of the spine as it curls around the body.

9 Carefully work out your dragon's hands and feet. I sometimes use my own hands as models for my dragons. You can also use pictures of the feet and paws of animals such as lizards, raccoons, or even dogs and cats. Take your camera to the zoo and snap some photos for use later on.

 10 This is the last step before you clean your image up. Determine any final details you want your dragon to have, like placement of scales (sketch them in roughly).

11 Erase your construction lines and draw thinner, finer lines, or trace the drawing onto a clean, new piece of paper. Now your drawing's ready to shade.

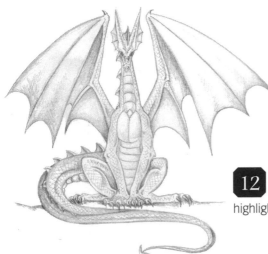

12 Begin your shading in light tones, to determine where you'll place your highlights and shadows.

SHADE WITH CARE

I'm left-handed, so I shade from right to left, so as not to smudge the paper too much. If you're right-handed, do the opposite and go from left to right. It's also a good idea to shade from top to bottom, for the same reason. If you're using a soft pencil, like a 2B, that smudges easily, use another piece of paper and cover the finished part of your drawing to help protect it from your moving hand.

13 Now your drawing's done! You can soften your pencil strokes by using a blending stump or simply leave them, if you prefer.

ADDING GENDER TO YOUR DRAGON

Now that you know how to draw the dragon's basic form, we can start looking at the dragon in greater detail. First things first…is your dragon a boy, or a girl?

You'll find that most dragons are fairly genderless and simply look male. That being said, you don't need to do much to make your dragon look male. Just draw your dragon strong, muscular, and fierce and there you have it—it's a boy! It's important to note that some species of dragon don't have truly defining differences between males and females, so that big, stocky, hungry-looking dragon could be a Mama!

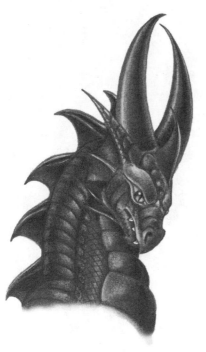

Male dragons shouldn't be soft looking. You can give your boy dragon plenty of horns, spikes, and teeth and he'll look great.

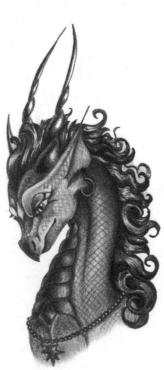

Making your dragon look feminine is a little trickier. You don't want to make her all-out human-looking, just having a dragon's head and wings (this type of creature would be an *anthromorph*, not a dragon). Let's take a close look at what's involved in making your girl dragon look, well, girly.

The key to making a dragon look female is to draw her as softer and more curvy. Female dragons can be fierce, strong, and menacing, but they shouldn't be too muscular or knobby or ugly. Smooth and sleek—that's the key.

Here are some things you can do to make your dragon appear more feminine:

- Give your girl dragon "hair" along her spine and on the back of her neck. It doesn't have to be too long, but if it's wavy or curly that'll help.

- Give her smaller front claws, more handlike and small. Don't make the claws too big.

- Add eyelashes. (They don't have to be real. I usually create the appearance of eyelashes by how I draw the scales above the eyes.)

- Draw your dragon extremely curvy and sleek—that is, have her neck curve elegantly like a swan's, and don't draw her too chunky or muscular.

- Don't make her scales too thick or rough-looking.

- Don't have teeth protruding from her mouth all over the place.

Of course, there are no set rules on how to draw a female dragon. These are just some tips and tricks that I've found useful. I'm sure you'll come up with plenty of your own.

DIFFERENT BODY TYPES

Your dragons can have a wide variety of physiques—just like people. Here are some of the more common ones that you'll likely want to try drawing.

THE MUSCULAR, STOCKY DRAGON

This isn't a dragon you want to run into when it's having a bad day! These dragons are strong, fierce hunters. Their bodies are made for strength, not agility, so their limbs tend to be thick and muscled.

1 Draw your beginning circles for the head a little closer together than normal. The neck will also be shorter, and the circles for the body should be large compared to the ones you did for your basic dragon, as this dragon's going to be thick and stocky. Even the tail's a little shorter than usual.

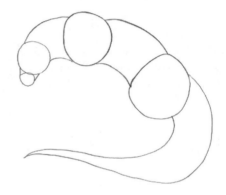

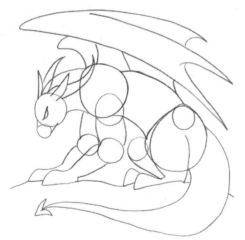

2 Add your dragon's arms, legs, wings, and hands. Because this fellow's so large, he may not be able to fly, even though he has wings. So don't worry if the wings aren't quite big enough to lift him off the ground, as they're for appearance only.

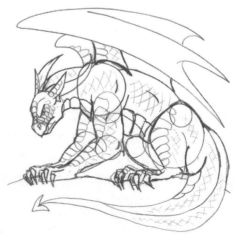

3 Sketch out the details over your basic layout. Add larger, blocky scales so he doesn't look as sleek and smooth, almost as if he's wearing armor! Work out any other details you want before you clean up or trace your sketch, such as the type of claws.

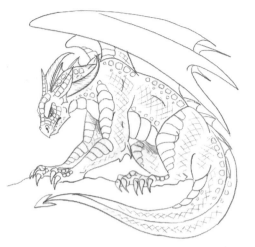

4 Trace your drawing onto a new piece of paper, or erase your construction lines. Add some more blocky scales along his spine and belly, plus a few teeth showing to make him look fierce. Begin your shading. Start light in most places so you don't end up making the drawing too dark. Add darker areas where you'll want the shadows to really show up, such as directly under the belly and wings.

5 Be careful not to shade your dragon too dark all over, or you'll end up making him look flat (rather than three-dimensional). Even black dragons have highlights on them where the light catches their scales—this is what gives your dragon great form!

THE LEAN, THIN DRAGON

If you guessed that drawing a thin dragon would be the opposite of drawing a muscular one, you guessed right! These dragons are quick and agile, with graceful limbs. But make no mistake—they're still a force to be reckoned with!

1 When drawing your basic circles for the head, draw them a little farther apart than you would normally, and make the neck somewhat longer. The circles for the body will be small and far apart, and your dragon should have a long, whippy tail.

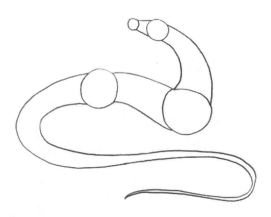

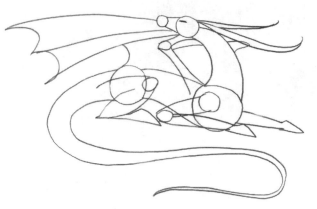

2 Even this dragon's limbs are long and lean. Draw small circles for the shoulders, elbows, and knees, for you want her to be lean and graceful, not knobby-looking. These dragons love to take to the sky, so draw large, luxuriant wings, even if they're folded down in your pose. (Or you can draw her without wings, for a wonderfully slinky-looking earth dragon.) Finally, add any other details you'd like, such as a set of long horns to really lengthen out her head.

3 Sketch the details of the dragon, including wings and limbs. Don't make her legs and arms too blocky or muscled, as you want her to be sleek.

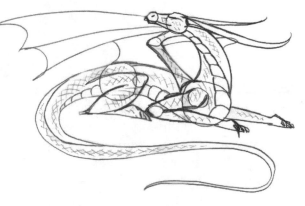

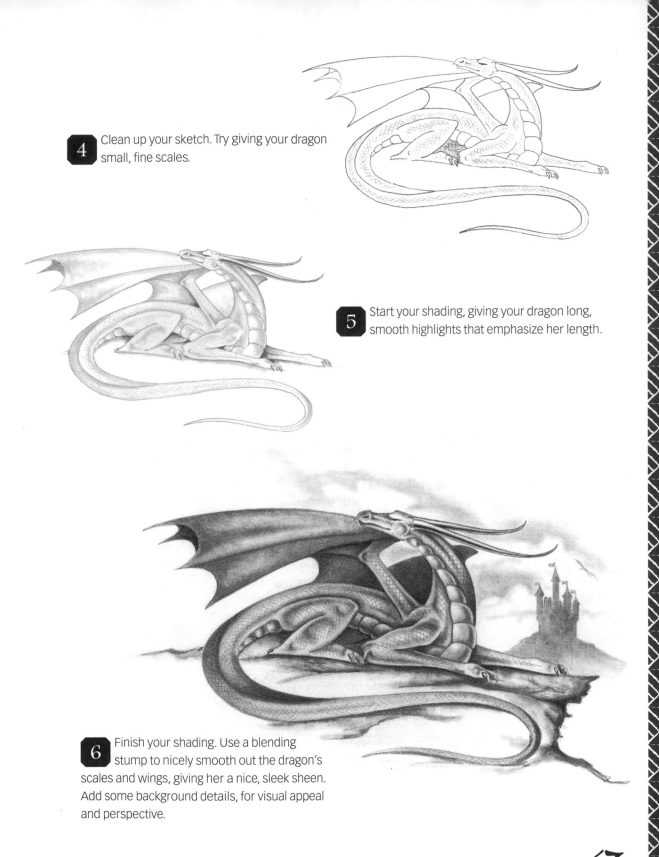

4 Clean up your sketch. Try giving your dragon small, fine scales.

5 Start your shading, giving your dragon long, smooth highlights that emphasize her length.

6 Finish your shading. Use a blending stump to nicely smooth out the dragon's scales and wings, giving her a nice, sleek sheen. Add some background details, for visual appeal and perspective.

THE BIG-BELLIED DRAGON

These dragons are notorious for eating princesses and causing havoc to castle dwellers. As you can guess from their big bellies, they're almost always hungry—so don't come too close when having one pose for you, or you might end up as a snack!

1 Drawing this dragon is similar to drawing a regular one, except the circles for the body should be very large, especially the second one near the back. The connecting lines will bulge out between these two circles, rather than cave in.

2 Typically, dragons that have put on a bit more weight than they should will have funny, small little legs and arms, so you'll want to draw small circles for them. They don't always have wings.

3 Work out the basic sketch, adding horns, claws, scales, and more.

4 Clean up your drawing, adding character to him as you work. This fellow already looks like he's ready to eat whoever comes too close!

5 When shading your dragon, add highlights that really suggest this fellow is roundish.

6 Your big-bellied dragon's complete. And he's ready to find a snack! In the meantime, he'll guard his treasure—maybe he'll get lucky and a "snack" will come find him!

THE BABY DRAGON

Like all baby animals, the dragon whelp is *cute!* Don't worry, she'll still grow up to be a formidable and threatening creature, but for now she's just plain adorable. So have fun with these little critters. There's no need to make them look fierce.

1 When drawing your basic layout, draw everything closer together. Make the circles for the body almost the same size as the large circle for the head. Start by drawing the head, overlapping the two circles a bit (since a baby dragon's head is short). This dragon will be crouching down, so you can't see her neck, but if you do draw a baby with neck showing, make it thick and short.

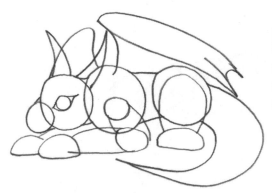

2 Finish adding your baby's wings, limbs, and any other details. These precious little dragons can't fly yet, so their wings will be small in comparison to their body. Their tails are also short, and their eyes, big and round.

3 When drawing the sketch over your completed layout, make sure your baby's limbs are good and chubby. Let's also give her large, rounded scales and a circular pupil in her eye to make her look more innocent.

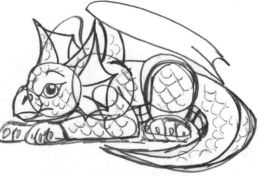

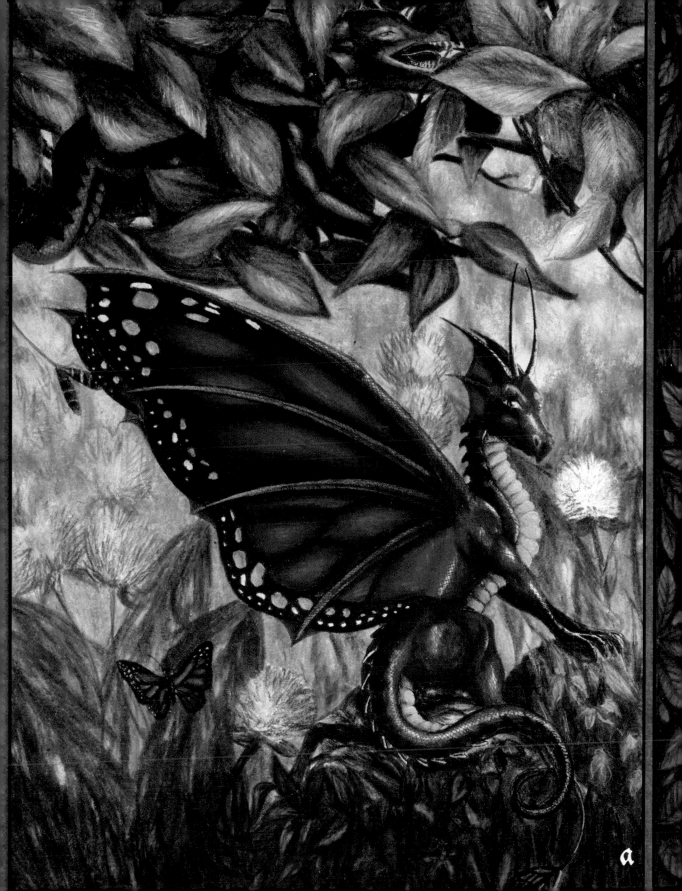

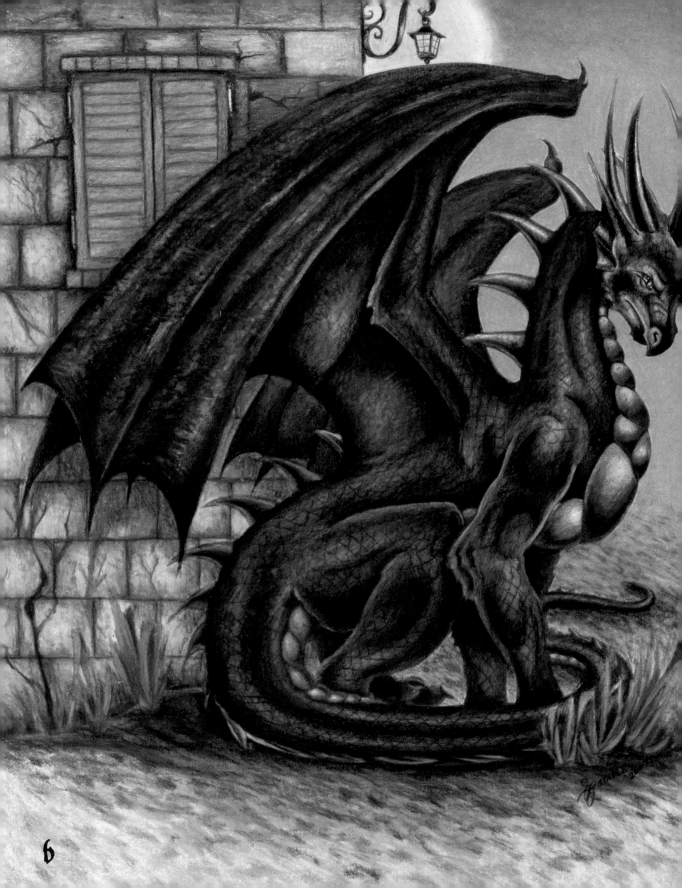

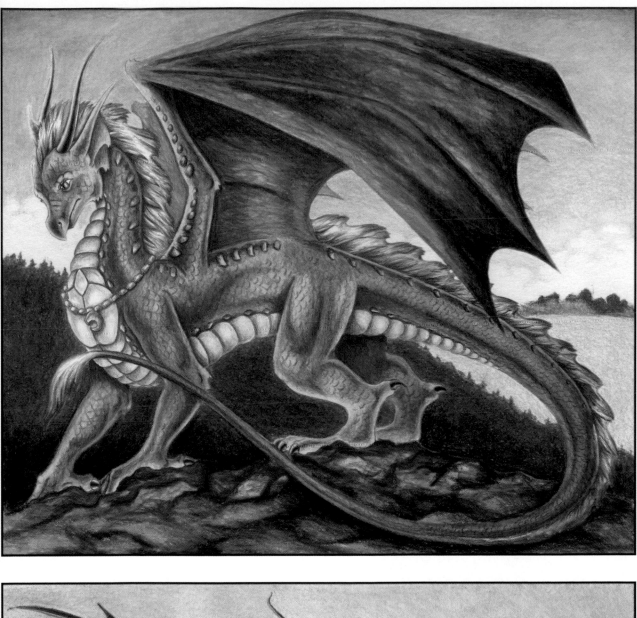

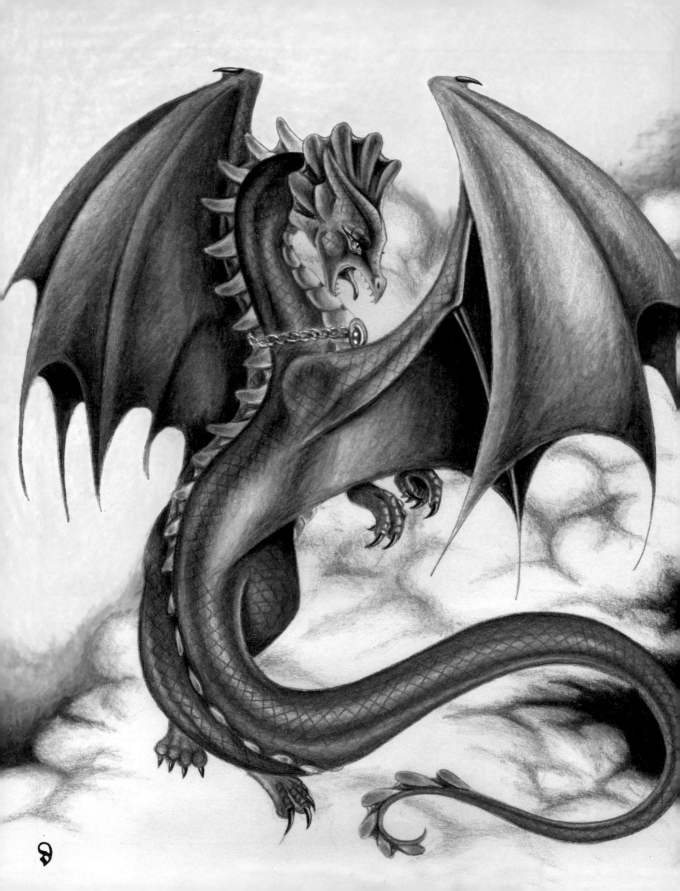

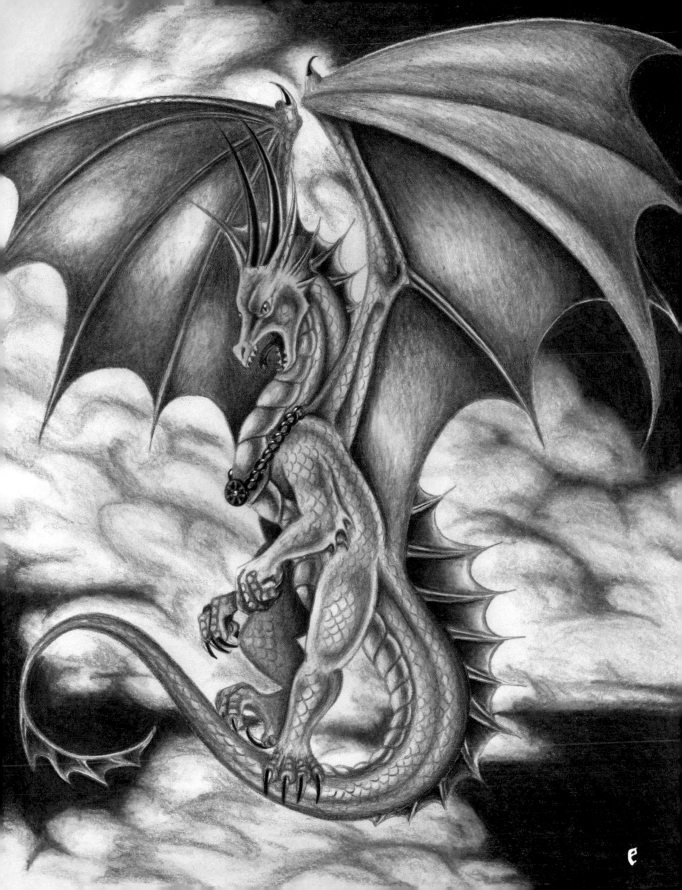

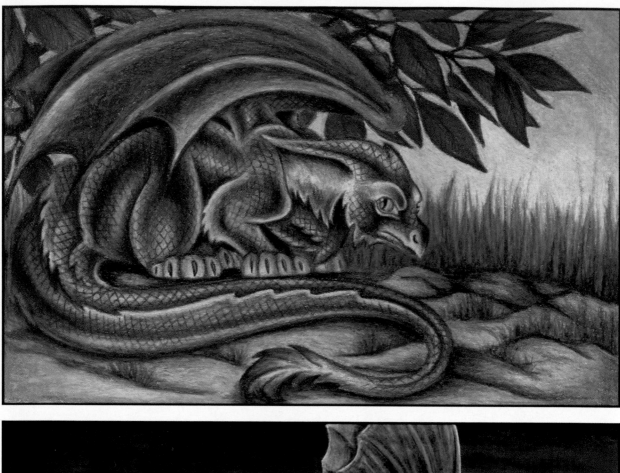

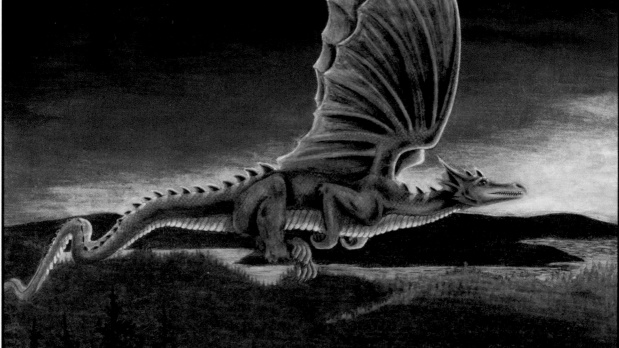

f

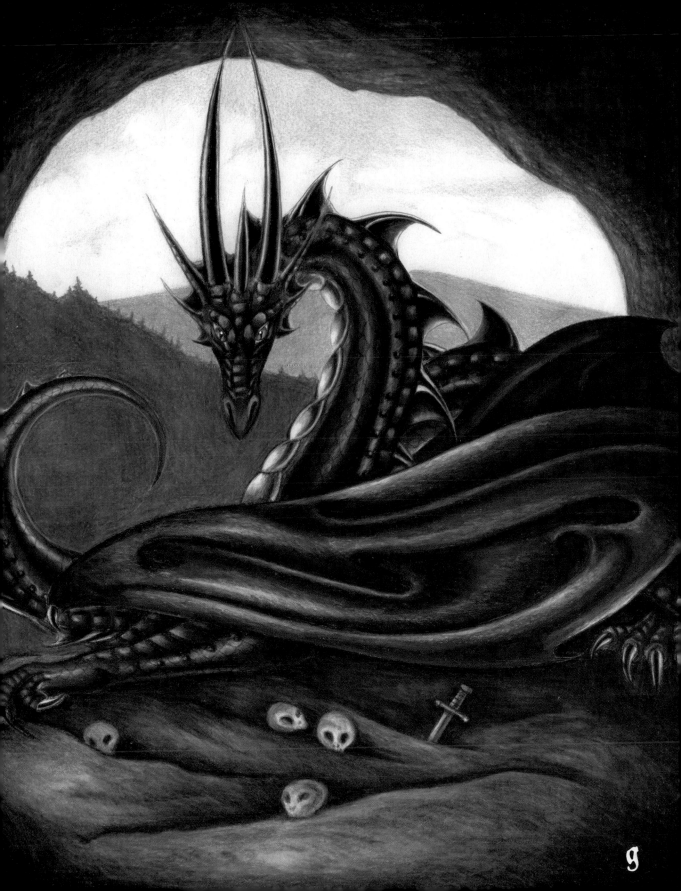

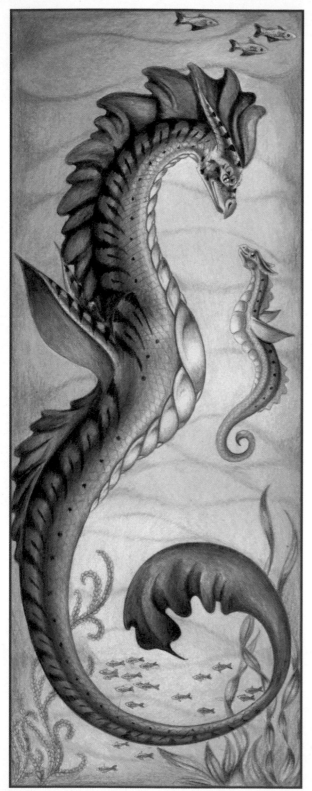
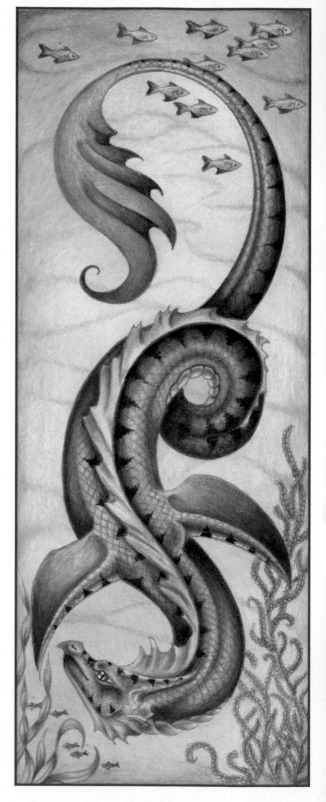

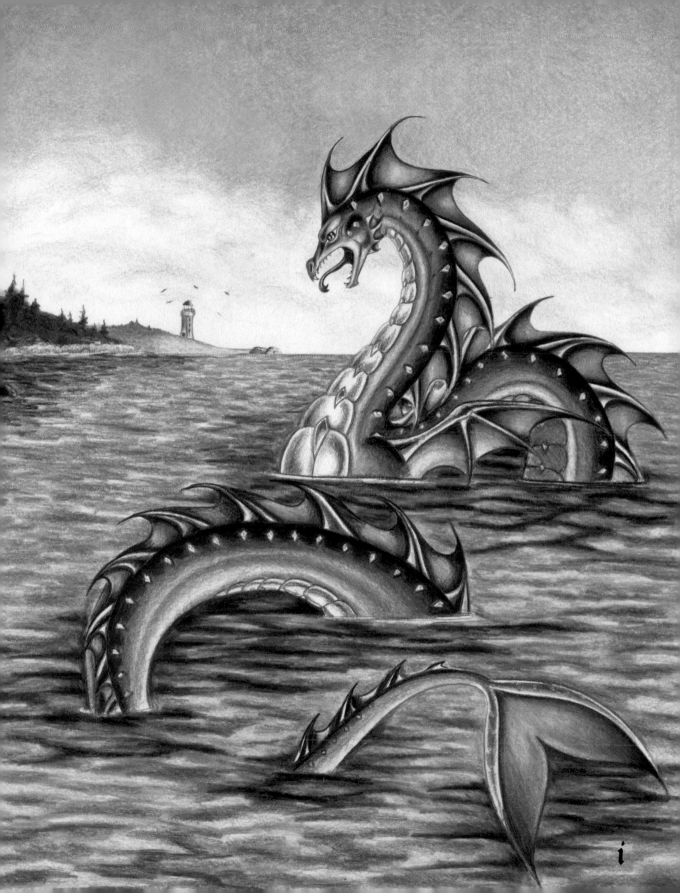

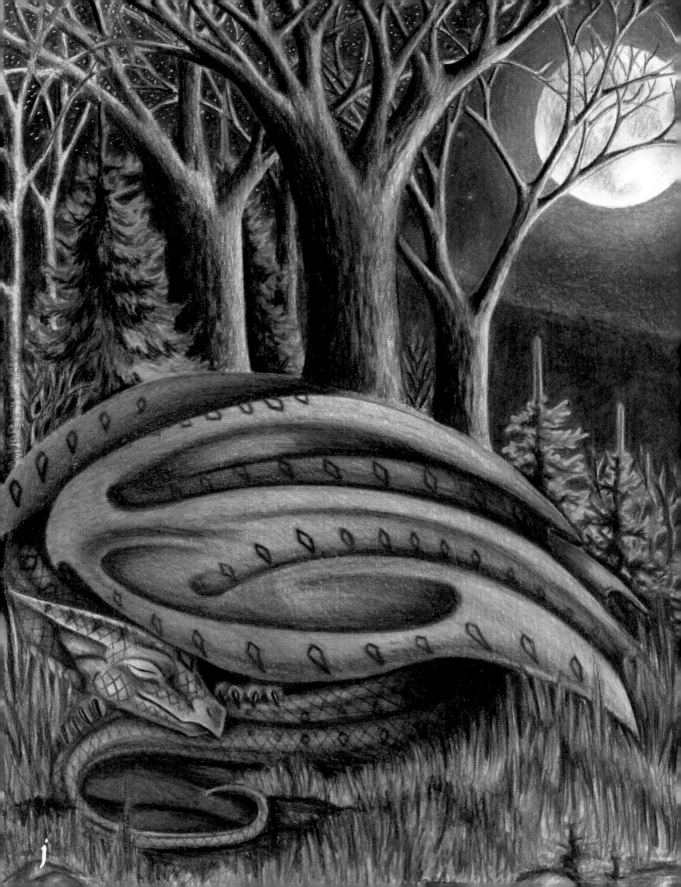

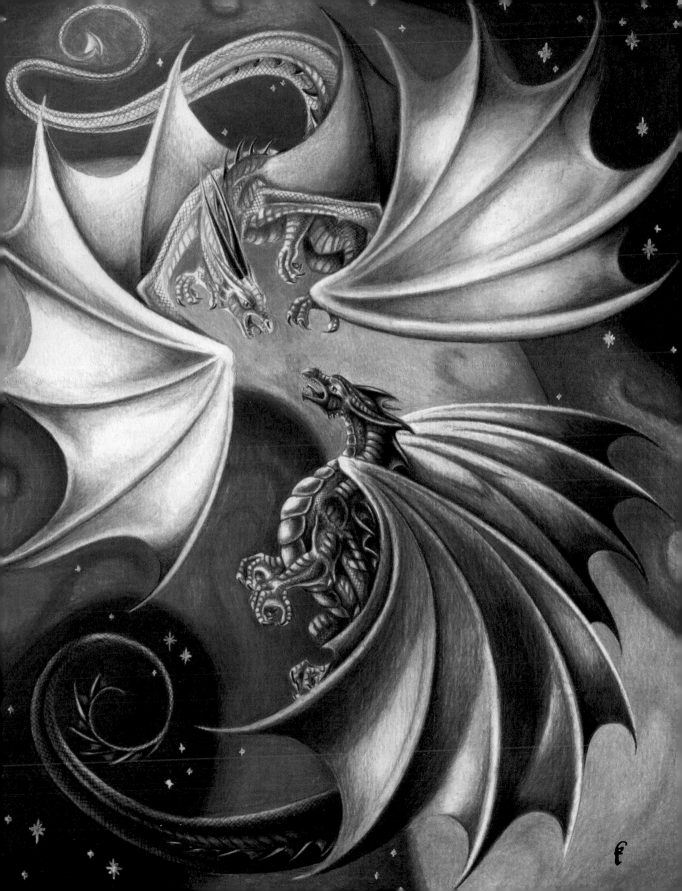

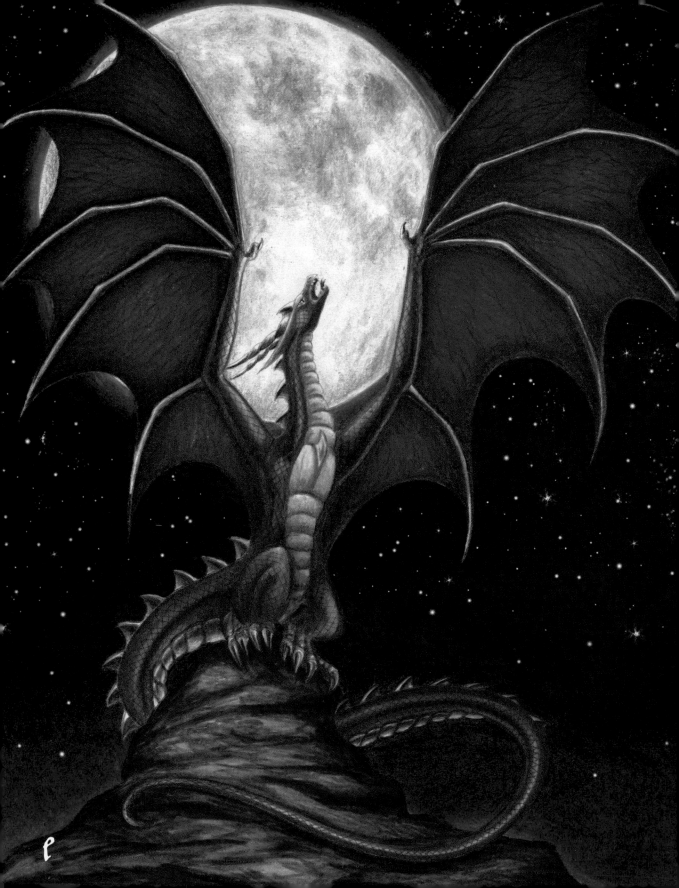

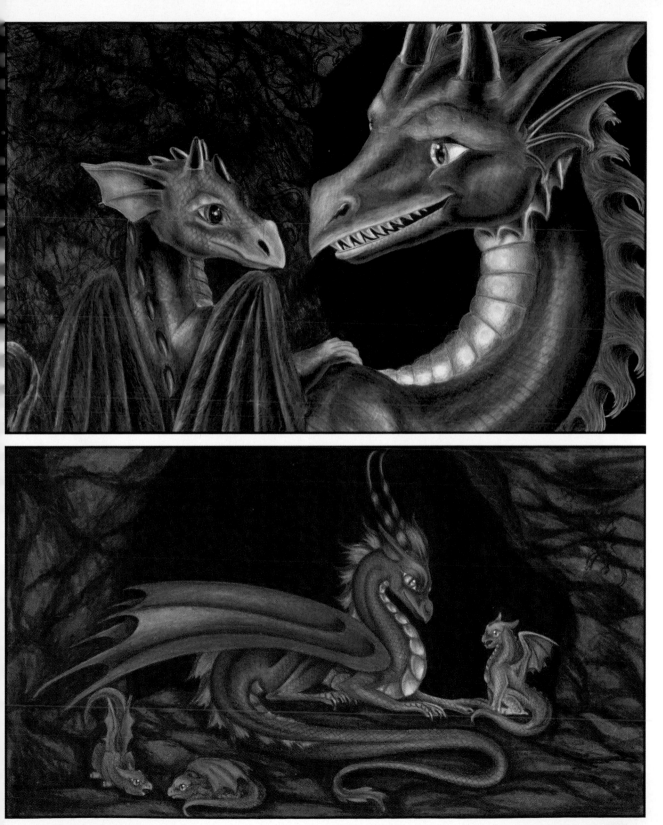

m

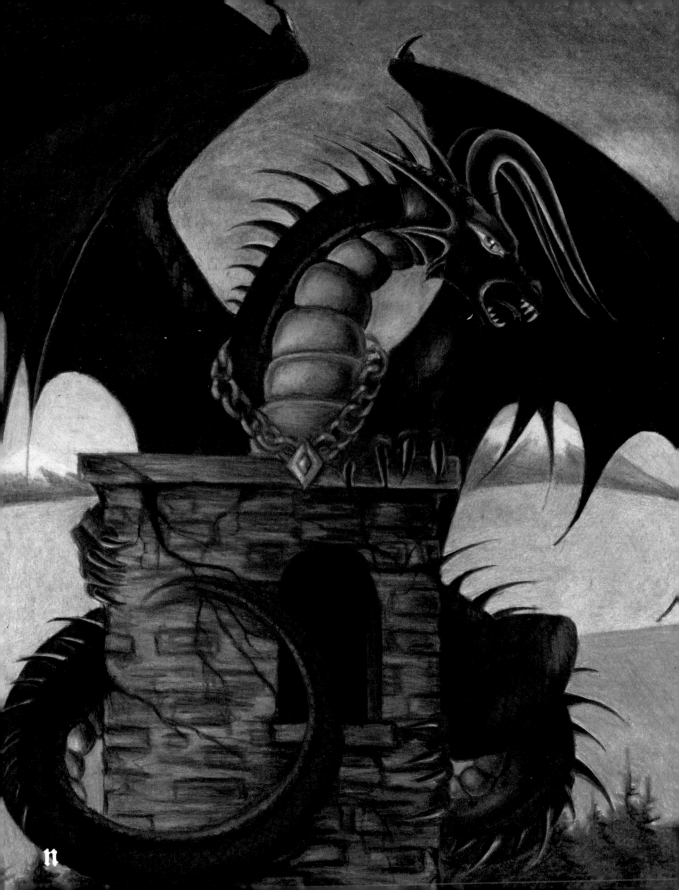

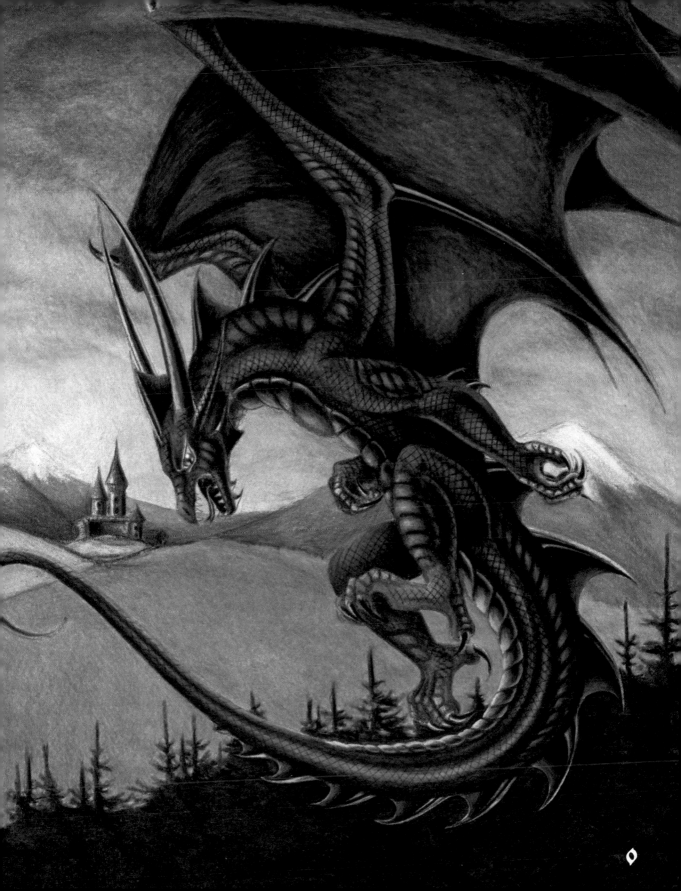

Here Be Dragons

PAGE **a**: "Deep Blue Assassin" (1996). This is one of only a few older drawings I still have. I drew it in grade 12, and it won several local art contests, while gaining me some commissions from people who saw it on exhibition.

PAGE **b**: "Lock Your Shutters, Lock Your Doors" (2006). This fellow's simply misunderstood, as he really doesn't want to eat anyone. Honest!

PAGE **c**: Top: "Elshara" (2006). A blue female dragon, Elshara causes mischief among the different cities and towns she visits. She's a character concept I came up with in university; I drew her several years later.
Bottom: "Over the Rooftops" (2007). You may not want to hear these feet landing on your roof! I wanted to do a drawing that would show a dragon's full wingspan in flight.

PAGE **9**: "Dragon of the Moon" (2008). This bejeweled dragon looks forward to the sun's setting so she can soar into the night sky.

PAGE **e**: "Dragon of the Sun" (2008). I drew this fellow as the matching partner for the moon dragon.

PAGE **f**: Top: "Autumn Shelter" (2008). I wanted to draw a dragon that looked both scaly and furry, so brown was the natural color choice.
Bottom: "Homeward Bound" (1995). This is one of the first color drawings I did of a dragon. I drew it in 1993, barely out of junior high, but reworked it a couple of years later (such as redoing the sky).

PAGE **g**: "A Cave with a View" (2008). I sketched this dragon a few years ago at my brother's apartment, in his sketchbook, and ripped it out to take home in case I ever wanted to finish it. Just goes to show that you should hold onto your doodles and sketches because you never know when they might come in handy!

PAGE **β**: Left: "The New Mother" (2008). A mother closely protects her new precious baby and welcomes her into the world.
Right: "The Proud Father" (2008). These two sea serpents were drawn as a set, though I think they frame nicer separately than together.

PAGE **i**: "Serpent at the Cove" (2008). Funny, but all my lighthouses end up looking a lot like the Peggy's Cove lighthouse in Nova Scotia. The trees also look very much like what you'd see along our eastern coastline. This is a good example of "drawing what you know!"

PAGE **j**: "Autumn Nap" (2008). Autumn's my favorite time of the year, when the leaves have turned bright colors and fallen off the trees. The air's crisp that time of year and the sky particularly bright and clear.

PAGE **f**: "Battle for the Night Skies" (2008). I liked how the black-and-white version of this drawing turned out, so I did a continuation of it in color, with the same two dragons in different poses.

PAGE **f**: "Calling Out the Night" (2008). I redrew this sketch about five times before I was happy with it enough to color. In the first four versions the dragon was breathing fire, but in the last sketch I added the huge moon and made him howling instead. Proving what a big difference a little change can make!

PAGE **m**: Top: "A New Little Brother" (1996). I drew this back in high school. This drawing always makes me think of my three younger brothers.
Bottom: "A Cave Full of Jewels" (2008). This mommy dragon may not have much gold in her cave, but her three little jewels keep her more than busy!

PAGE **n**: "Sentry at the Wizard's Tower" (2008). This fierce red dragon guards his tower from any oncoming attacks.

PAGE **o**: "Hunter of the Evergreen Woods" (2008). What could be scarier than a dragon that blends in with his surroundings?

p

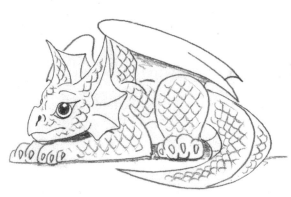

4 Your baby's almost ready to shade. When drawing the scales, you can still use lines to create a crisscross grid pattern, but then draw out each scale separately, tracing over your gridline. This will give you nice rounded, individual scales that follow a consistent pattern.

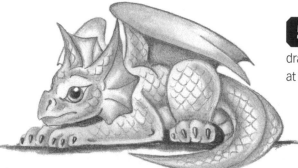

5 Begin shading. Because you want to make this little lady look soft and cute (for a dragon, anyway!), try using a blending stump a bit at this first step, to keep the tone smooth.

6 Aw, see how cute she is? Your baby dragon's ready to explore the world of, er, paper I guess! Continue to use the blending stump until she's complete, so that she has a soft appearance and virtually no pencil lines are visible.

THE AGED DRAGON

Experienced and wise, these elderly dragons have lived a long time and have many fascinating stories to tell. They're often battle scarred, with tattered wings and jagged horns, but they're still strong and resilient. There's no need to make your dragon look so old that he's too frail even to catch a mouse! (Unless you want to, of course.)

1 Drawing an old dragon is similar to drawing a basic dragon, at least for the first couple of steps. Draw your basic circles and shapes, to determine a pose.

2 The next step is to add the rest of the limbs, wings, and horns. You're setting the stage for some character development here!

3 Make the horns seem battered and rough and the wings tattered-looking. Try adding a beard if your dragon's male. Don't make your dragon look too thick or muscled, as he's old and past his prime.

4 Erase your construction lines and clean up any sketch lines that you've made too thick, or trace your drawing onto a new sheet of paper. Add lines under his eyes to make him look older, plus some wrinkles here and there.

5 Begin your shading. Don't worry about the lines being too rough-looking, as these will help make him look somewhat ragged and worn with age. Make the wings look tattered, and add some rips and wrinkles to his spikes along the spine.

6 Your ancient beast is complete! He's old and has fought (and won) many a battle. Perhaps he has some tales of winning treasure he can tell you…or maybe he's thinking you'd make a nice, easy meal! (Well, would you…?)

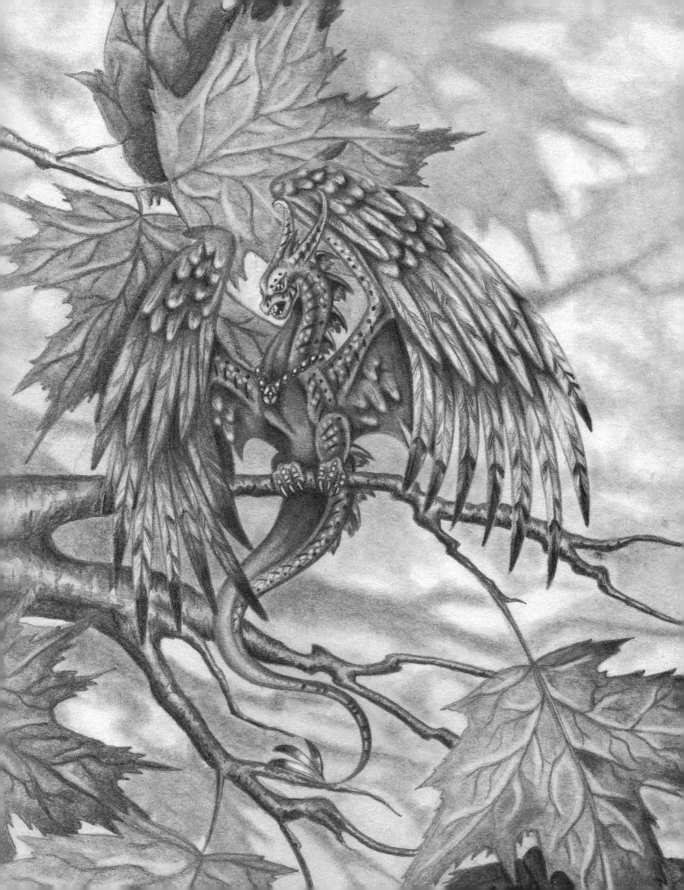

Section 3

ADDING DISTINCTIVE DETAILS

Like many creatures, dragons have special characteristics all their own. These can change, depending on what type of environment a dragon lives in, or how menacing you want it to look.

In this section we'll take a close look at many different features you can give your dragons to truly set them apart from others. Whether they have an impressive set of horns and tusks on their head, or fierce-looking barbs running down their back, or fuzzy fur over their entire body, you can choose which details to give your dragons to make them truly your own artistic creation.

Keep in mind that everything in this section is designed to give you *ideas*, more than anything else! So have fun, and before long you'll find there are certain details that you like adding to your dragons more than others, and you'll be well on your way to having your very own "dragon" style. I wouldn't be surprised if you created a dragon that has never, ever been seen before!

HORNS AND HEAD PLATES

Horns and head plates are a creative way to give your dragon a unique look. They truly affect the dragon's personality and can function as large and dangerous weapons, as strong protective "helmets," or even as elegant, awe-inspiring headdresses. You might want to try roughly tracing your dragon's head a few times onto a new piece of paper, then experiment with giving it varying horns and head plates, just to see how they'll affect your drawing, *before* you make the final decision.

Pointy Straight Horns

These can be pointing up or leaning back. They're quite easy to draw, and you can make them a shiny-looking black by adding contrasting highlights and shadows.

Curved Spiral Horns

You can also have horns curve at the ends, and add a spiral effect to them. Make the spirals smaller and closer together, or larger for a more noticeable effect.

Ram Horns

These horns spiral down around the dragon's head and look best if the dragon has no ears.

Bull Horns

Sticking either upward or outward from the head, these horns will give your dragon a powerful, strong look.

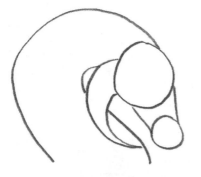

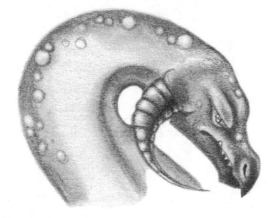

Downturned Horns

Make sure the horns are curved forward, for a menacing effect.

Dinosaur Horns

If you give your dragon dinosaurlike horns, make sure that the beast still looks like a dragon, with a long, curving neck and an impressive headdress. After all, you don't want your dragon to resemble a weird-looking dinosaur!

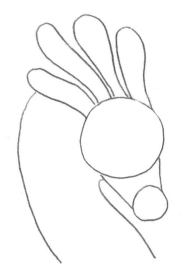

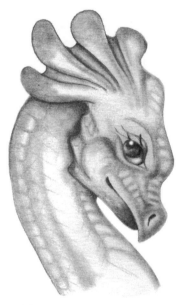

Knobby Horns

Rounded, knobby horns and head plates are great for female dragons and young dragons. Such horns give them a softer, gentler look.

Random Made-Up Horns

Of course, you can always make up horns, as well! Let your imagination run wild, but take care that your dragon doesn't end up looking like he's got a strange superhero's symbol stuck to his head.

RIDGES AND SPINES

You can add character by the type of spines you draw along your dragon's neck and back. Long, dangerous spikes will make your dragon look truly treacherous, while small rounded ones probably won't. Of course, you can always leave your dragon's spine bare for a sleek, sinewy look.

Pointy

Pointy triangles are one of the most traditional and common spikes that you'll find on dragons (at least, the dragons *I've* known!). They usually have a bit of curve to them, like a talon or a shark's fin.

Finlike

Spikes that look like fins are common on water dragons and sea serpents. The spines are wavy, with flexible webbing in between.

Curved Spikes

Long spikes will make your dragon look really menacing. They'll look superdangerous if you add a bit of a curve to them.

Wavy

A great choice either for furry dragons or for female dragons is wavy spikes. You can make the wavy tendrils look more like "hair" by giving them some texture, or you can have them look more like tentacles by drawing them smooth and shiny.

Feathered

Make feathered spikes any way you like, whether they attach as a group of small feathers (as in this example) or stand on their own as larger, long feathers. They'll probably look better having some sort of pattern to them if your dragon has regular old-fashioned scales.

Knobby

These almost remind me of a horse's mane all tied up to look fancy! This is another great choice for female dragons.

Random and Straight Spikes

You can have large, straight spikes rising up in a random pattern, to create a more chaotic-looking beast.

Rounded

What could be better for a cute little baby dragon? These will also work well on any gentle-looking creature.

TAIL TIPS

Don't forget the tail! These illustrations are just ideas. Some tail tips are commonly seen on dragons, like those with a pointy triangle tip or with a spade-shaped tip. Others are less common, such as a tip in the shape of a fan. Try playing with different shapes to see what you can come up with. Have fun and be creative!

Spade
This is one of the most commonly seen tail tips on dragons. It's great for making precise jabs at objects.

Spiky
This is a most dangerous tail tip. You don't want to be battling a dragon that displays a set of these, as they're sharp as razors!

Pointy
Another classic tail tip for dragons, the pointy style helps provide a bit of balance and weight to the end of the dragon's tail.

Wavy
This tail tip matches the wavy spikes in the previous section, and is great for female dragons or for furry ones.

Fishlike or Whalelike
This fishy-looking tail is perfect for seafaring beasts such as sea serpents or any dragon that lives primarily along a coastline.

Rattlesnake

If you hear this tail rattling, start running! This tail is more common on smaller dragon varieties that want to scare off larger predators.

Butterfly

This type's great for small garden dragons and fairy dragons. They can use their innocent-looking tail to lure prey in closer, before they pounce!

Finlike

In this case, the dragon's ridge that runs along his spine just tapers down right to the end of the tail.

Fan

This type's more common on female dragons. The fan can be either fully opened or relaxed and slightly wavy.

Feathered

You can pretty much add feathers to the end of a dragon's tail any way you want. In this case, they're fanned out so you can see each individual feather, but you can easily overlap them if you want.

Tuft of Fur

This little tuft of fur is perfect for cute little furry dragons…or big mean-looking furry ones, whatever you prefer!

Made Up

Of course, you can always create your own funky tail tip! This one looks like it would be good for pinching, but actually it doesn't have a function other than looking cool.

SCALES

Dragons are usually monstrous, scaled beasts. Luckily for you, there are many types of scales you can give them. Of course, you can draw a smooth-looking hide, or a furry or feathered skin, depending on what look you want. But for now let's consider some of the types of scales you can give your dragon and how they function within your drawing. It's always fun to mix things up a bit, too, by giving your dragon several types of scales on various body parts. For example, you could give him platelike scales on his back and along his neck, thick overlapping scales just below the plates, and then small scales nearer his belly (drawn using a grid-style scale).

Grid

The easiest and quickest way to give your dragon scales is to use a grid. Simply draw crisscrossing lines at an angle over the dragon's body. The closer together you draw the lines, the finer the scales will look, which is great for sinewy, slinky dragons.

Overlapping

It's easy and simple to draw overlapping scales, but it takes a bit more time than drawing grid-style ones. Here the scales are all evenly distributed, are the same size, and overlap with a slight curve at the end. It's often useful to draw an actual grid underneath (very lightly), then draw each individual scale over the grid.

Fishlike Stylized

This type of scale is common on Oriental dragons. The scales are rounded and can have a quite defined edge around each one.

Irregular and Rocky

Great for more animal-looking beasts, these irregular scales can be drawn either very close together, or spread out a bit for a bumpier look.

Snakelike Diamonds

Each one of these scales seems to pop separately off the dragon's hide. They can take a long time to draw, but they'll make a highly dramatic effect!

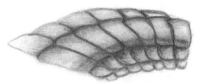

Plated

Plates are great for large, muscular battle dragons. They make the beast a little less flexible, but provide terrific protection during battles.

Circular

You can draw the circles either the same size or all different sizes. They should probably get smaller (or completely disappear) closer to the dragon's belly, otherwise your dragon will look like he's got a strange case of chicken pox!

Fine Grain

This method of drawing scales lets you give your dragon's hide a bit of texture without having to draw each individual scale.

UNIQUE MARKINGS

In addition to drawing different kinds of scales, you can give your dragons unique markings that either go along well with scales or entirely replace the need for them. Here are just a few ideas, to boost visual interest. You can mix things up, for an even better effect.

Adding unique markings to your dragon is a clever way to make her (or him) really stand out from the dragon crowd, as well as add interesting detail to your drawing. It'll take a lot longer to do, depending on how much detail you add, but it will be well worth it in the end! You also need to think about the markings' placement and function. Do you want them to look like they're a natural part of your dragon's skin? Will they replace scales entirely? Would you like them to look more like tattoos? These are all important questions, because they'll affect how you draw the markings and where you place them on your dragon.

Blocks
Any type of square or rectangular marking will likely look best if you use them to replace scales, or have their pattern match up with the dragon's scales.

Diamonds
Whether big or small, diamonds can be fun—*and* a girl dragon's "best friend"!

Rocks
Similar to having rocky scales, only the rocks in your pattern and markings don't touch one another. Also, they don't have to cover the dragon's entire body.

Spots

Use spots to create an interesting pattern along the dragon's neck and spine, or around the hands and mouth (to look like warts).

Stripes

Thicker stripes will create a more dramatic effect, while smaller ones will blend in better with the dragon's scales. Just keep in mind that you probably won't want to continue the stripes too far down the belly and undersides of your dragon, otherwise they won't look natural.

Swirls

These are most likely not going to look very natural, but hey—they're fun and funky!

Zigzags

Creating interesting zigzag patterns on your dragon can be a hoot, but don't go overboard, as they can easily become overwhelming (or dizzying) to look at.

FEATHERS AND FUR

Feathers

The most difficult thing about drawing feathers is how much *time* it takes! Feathers, one of the miracles of nature, can be very time-consuming, as each one can have a lot of detail.

Feathered dragons (in case you didn't know) are rarer than their scaled, leather-winged cousins. How many feathers your dragon has is up to you— from a simple headdress, or large feathered wings, or a full-fledged feathered beast, you get to decide. Just be careful that you don't overfeather your dragon, or it'll end up looking like a really odd bird that might exist only in your dreams.

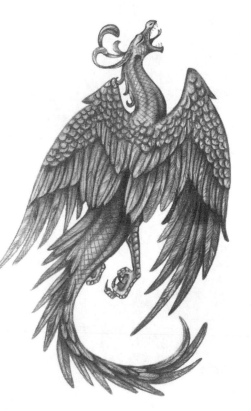

Feathers can also be quite different, depending on where they go on the body. Flight feathers are long and strong, so that they can catch the air without bending and breaking. They're still flexible, though, so you can give them some movement. Feathers located on the belly and around the legs tend to be softer, shorter, and more flexible still. Underneath those feathers are light, wispy ones (like goose down) that can come loose during quick movements.

Fur

It can be fun to draw fur, which can create a really distinctive look for a dragon, except maybe one that lives in a hot climate. Whether you're trying to draw a kind and gentle forest sage, or a mangy-looking dragon-beast, a bit of fur—or a *lot* of it!—can give your beast a "wild animal" look. Grrrr!

When drawing fur, you can make it fine and short by using small, short brushstrokes, or thick and wavy by drawing the fur in chunks. Although fur has a nice sheen, it's not as shiny as scales. So you don't need to make your highlights as bright where the light hits them.

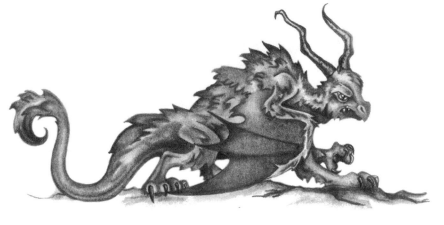

FIRE BREATHING

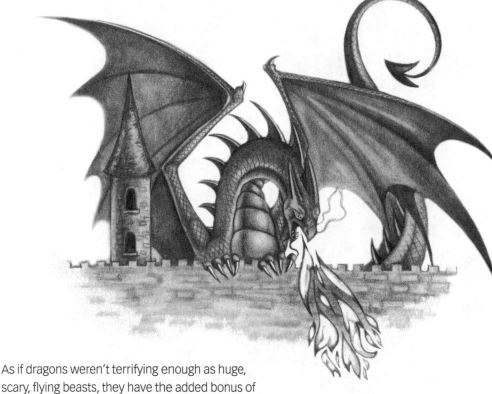

As if dragons weren't terrifying enough as huge, scary, flying beasts, they have the added bonus of being able to "breathe" fire (actually, *exhale* fire), allowing them to destroy entire villages without even having to touch the ground! (Of course, not all dragons will condone this behavior. Some feel it's only fair to stomp around and make lots of noise to scare away the villagers.)

The dragon's ability to breathe fire is a fundamental ability of this great creature, so at some point you'll probably find yourself drawing it. But how, exactly, do dragons go about breathing fire, anyway? When drawing them we're mostly concerned with how the flame comes out of their mouths, so let's take a look at the two main ways a dragon can breathe fire.

STYLES OF FLAMES

How you draw your fire is strictly up to you. It depends on what your dragon's doing and what you think looks better for your drawing. Having the fire spread father apart and separate gives you more of a range that you can have the flames cover. Having one solid flame will probably look better when it's moving in one direction, straight at a dragon's enemy.

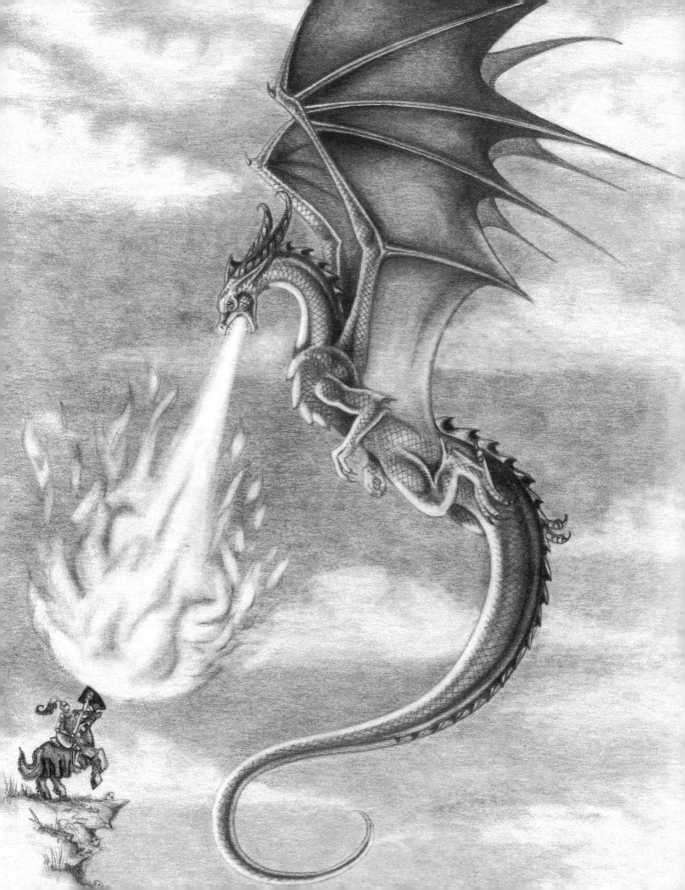

INDIVIDUAL LICKS OF FLAME

When drawing licks of flame coming from the dragon's mouth, start the flames just outside the dragon's throat. This means that though the first lick of flame can start from within the dragon's mouth, it shouldn't actually be touching him anywhere. The flames will be darker on the outside than inside. Keep in mind that fire gives off light, but also contains different hues of color (such as white, blue, yellow, and orange), so it will have darker areas as well.

STEADY STREAM OF FIRE

This method of fire-breathing has the fire actually start from within the dragon's throat, or far enough back in its mouth that the entire mouth will be filled with flames. The flames shoot out in a steady stream toward the dragon's target, and will be very bright in the center. Although licks of fire will come off the blast, it's mostly one large attack (like a fire spitball) that shoots forward. The "fireball" will grow wider as it gets farther away from the dragon's mouth, creating a more deadly-looking blast.

Why does a dragon breathe out fire?

"So, my dragon can breathe fire," you may be thinking, "but what's the point of that?" A dragon may breathe fire for many reasons—to warn you they may attack, or to flex their personality a little, or even just to show off! When drawing them breathing fire, you need to make them look like they have a reason to shoot fire out of their mouth—so you probably won't want to choose a sleeping pose.

◼ Almost any attacking pose will look good with fire-breathing added to it. But for dragons attacking each other with breath weapons, set the drawing up carefully to accommodate two sets of flames, without looking too cluttered.

◼ Whether a dragon is attacking a knight, an entire castle, or another fantasy creature, flames can add interest to your drawing and make your dragon look truly terrifying. (That's your goal, right?)

◼ Sometimes dragons will use their fire-breath weapon as a show of power as well, so if you feel that fire would look good in your drawing, just lightly sketch in the flames first.

◼ Remember that flames are a source of light, so don't draw them too dark. Also, don't be afraid to use that eraser to lighten up the center of your flames after you shade. (I almost always end up having to do this!) Adding a background (sky, or a castle wall) that you can set the flames against can help.

◼ Finally, if you think you want to color your drawing, give your dragon's flame some interesting shades. Dragon fire has an element of magic to it anyway, so try giving that icy mountain dragon light blue and white flames, for a neat effect.

ADDING ADORNMENTS AND JEWELRY

Ah, the greedy dragon—a creature famous for hoarding its treasure, even to its own demise! Besides sitting on treasure, dragons can also wear it. Choose jewelry that suits your beast and her surroundings (or *his*—guy dragons sometimes like bling, too).

Chains, necklaces, and pendants are easy ways to add a little something extra to your dragon. You can draw thick chains around a dragon's neck, as though he's a fierce beast that has been captured and threatens to escape. Or you can give your dragon a fancy chain and pendant, suggesting that she's an intelligent (though still fierce and possibly not so nice) creature.

The style of chain or pendant you create will depend on what type of dragon you want to draw. For example, a gentle forest dragon may have a necklace woven of leaves. Here are a few ideas of subject matter you could use for pendants.

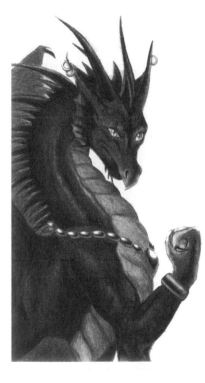

Rings, bracelets, and earrings also make fun additions to a drawing and, again, usually denote intelligence, as lesser beasts simply won't go to the trouble of piercing their ears!

MAGICAL ITEMS

Beware the cunning devil that uses magic to do his bidding…or thank the gentle giant that uses it for peace! Magic can play a fascinating role in a dragon's life, and magical items can become a prized piece in a dragon's hoard of treasures.

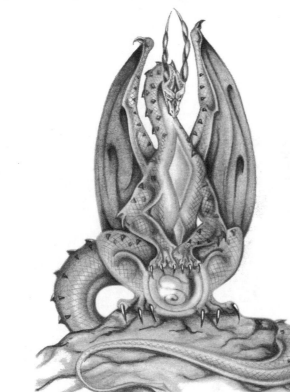

You can choose to give your dragon magical powers on his own, such as the ability to create lightning. Or you can give her a magical item to draw power from, such as a crystal ball granting your dragon a glimpse into the future. Some creatures of legend even wear magical items on their forehead, some wear a pendant or a ring, while others simply carry the item with them (such as Oriental dragons proudly clutching their pearls).

Magical swords and wands can also have a huge impact on a dragon's life and can add other elements of interest to your drawing. Whether it's a sword designed for dragon slaying, held by a dangerous knight, or an enchanted gemstone, *you* get to decide how you want your dragon to interact with the item to create a dynamic scene!

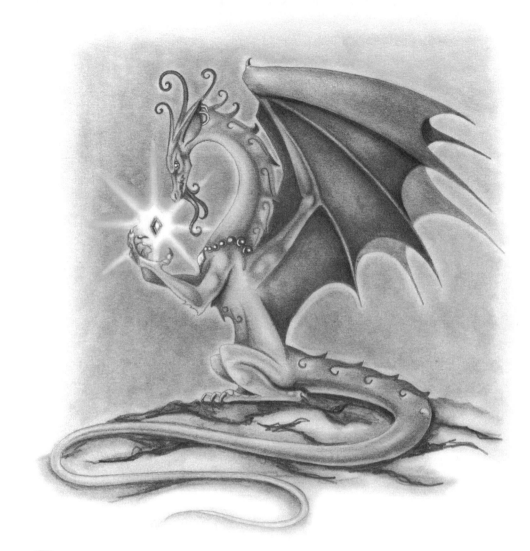

You can also create a little visual interest alongside your dragon drawing by adding some magic rays, stars, and sparkly things. If you're not sure what to give your dragon, look around your home for ideas. Virtually any interesting object can be incorporated into your art, and then you'll have something to use as a "model" for your art. Take a look at your family's curio cabinet or shelf of knickknacks, or get ideas from necklaces, earrings, buttons, candle holders, fancy perfume bottles, objets d'art, or old or foreign coins.

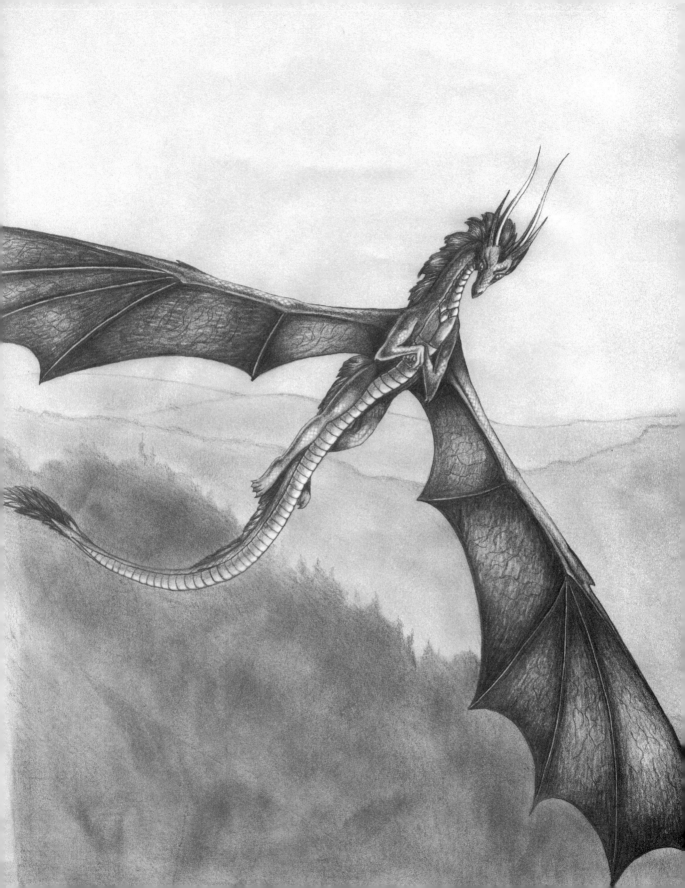

Section 4

CREATING DYNAMIC POSES

Now that we've looked at the many different parts of dragons, body types, and special details you can add to your dragon—and now that you've tried drawing the basic forms and elements—it's time to think about what your dragon's actually doing.

Giving your dragon a dynamic pose is a wonderful way to add action to your drawing and to make your creature look scary or enchanting. You'll probably find that certain poses appeal to you more (and are easier to draw) than others, so don't worry if it takes a bit of practice to get some of them down pat and in your drawing hand.

I've illustrated some of the many options you have. You may find that mixing several of the poses together works well for creating new ones. You may very well come up with an exciting dragon type and a creative pose never seen before by anyone! Don't be afraid to stray from these basic poses, as there are ultimately as many dragon poses to draw as you can dream up. Most importantly, have fun as you bring your dragon to life!

STANDING

We've already looked at a dragon standing on four legs in "The Dragon: Side Profile" tutorial in Section 2, so now let's take a look at a dragon standing on two legs.

1 Start once again with your basic body shapes. Because the dragon will be standing on two hind legs, the body layout should be more vertical, so start the circles for the head higher up on the page. A dragon can't stand completely straight up and down like we can, so the neck will arch back to help balance the body. The front of your first "body" circle should just about line up with the back of the larger circle you drew for the head. The circle for the hips will be farther back again, and the dragon's tail must stretch out far behind its body to help balance and keep the critter upright.

2 Determine what type of limbs you want your dragon to have. Make sure that the limbs' thickness matches the rest of the dragon. If you drew your circles closer together and drew the tail shorter, then the limbs should be shorter and thicker as well.

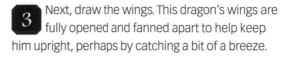

3 Next, draw the wings. This dragon's wings are fully opened and fanned apart to help keep him upright, perhaps by catching a bit of a breeze.

4 Decide what type of feet and claws you want your dragon to have, then sketch out shapes for any other details you may want to add—such as horns, ears, and spikes. Your dragon's feet should look sturdy and well-planted on the ground, as they must be able to support his entire weight.

5 Now that your layout's complete, you can finish your sketch by working out the detailed lines. Fill in the dragon's eyes and face, as well as any muscle definition.

6 Erase your construction lines and clean up your line work, or copy your drawing onto a new piece of paper, then your dragon's ready to shade. Now add more muscle tone to suggest some heft and strength.

7 You can use a blending stump to smooth out your lines and start "coloring" in your dragon. I like using this method of shading, because it gives nice, solid tone underneath the final layer of pencil. Make sure you don't get rid of all your white highlights, though! There should be areas where you don't smudge at all. (If you don't have a blending stump handy, try creating one by rolling up a small piece of paper and making it pointy on one end.)

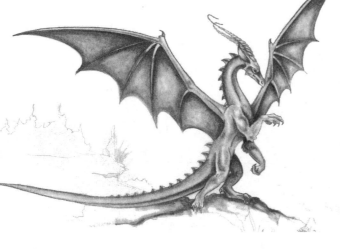

8 As you can see in the previous step, using the blending stump really flattens out the drawing. This is because it blends all the shades together so your dark areas don't look as dark. Because of this, you now need to go back over your drawing and fill out the dark areas once again. Finish up your shading and add a background if you wish. Now that there's a background, you can do a bit more with the tail. It should still go mostly straight back, but you can have the end of it wind a bit into the scenery, which makes the dragon look more as if he's part of his environment rather than just posed in front of it.

SITTING

Let's now take a look at drawing a dragon that's sitting down, from a side profile. (We tackled drawing a dragon in front profile in a sitting position in Section 2.)

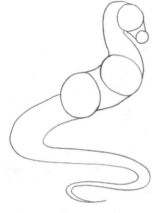

1 The basic layout for a sitting position is very similar to that for a standing position. The body is fairly vertical, and the dragon's neck relaxes into a graceful curve. The only difference is that the tail probably won't go straight back, since the dragon's relaxing, so let's draw it curving in front of him instead.

2 The dragon uses his front legs (or arms) to support himself while sitting, and the knees come up so he can sit back on his rear. Because our dragon's quite compact, let's attach the hind legs just below the rump circle this time, so that his knee will actually sit roughly in the center of that circle.

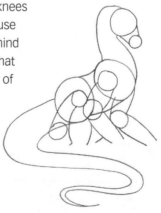

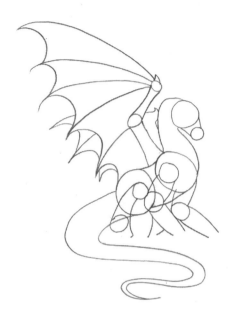

3 You can draw the wings completely closed, partially folded, or fully open. The more closed the wings are, the more relaxed the dragon will look, so he'll be less able to take off quickly when he has to.

4 Finish adding your dragon's basic parts, such as claws, horns, and ears. The front claws should look as if they're helping to support the dragon's weight, and not just hanging limply.

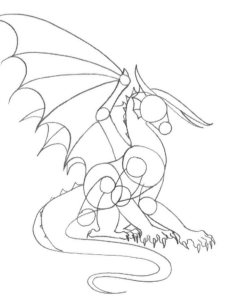

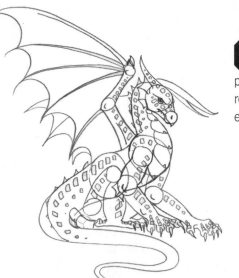

5 Draw in some basic details over your layout, such as the dragon's eyes, chest plates, and any unique markings. This dragon has rectangular plates rather than scales, and large, expressive eyes.

6 With the construction lines gone and the detail lines cleaned up, he's starting to look pretty good! Now he's ready for shading.

7 Begin lightly shading, adding shadows under the raised scales (or plates) along the dragon's skin. Blend together some of your shading to make deeper, larger shadows and to give your dragon's hide a nice tone. Don't shade the raised scales, or they won't stand out.

8 Darken your shadows and areas around the dragon's muscles to really make his muscles appear well-toned. (Make sure you leave the highlights light or almost white so that his muscles look round and not flat.) Add a thin shadow under each raised scale to make it pop off the page—and you're done! These dragons are guarding a castle wall. (Someone must have offered them a lot of treasure to get them to do that!)

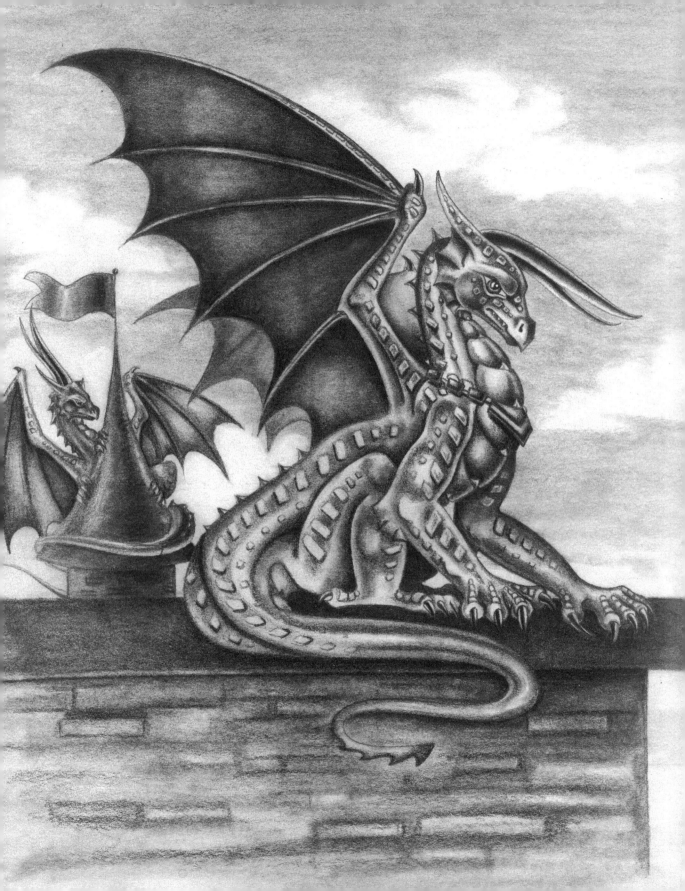

LYING DOWN

Drawing a dragon that's lying down is similar to drawing one that's sitting. But the body will display more horizontally and the neck will arch upward, leaving part of the chest touching the ground.

1 Draw your circles for the head, and have the neck curl downward so that it ends partially underneath the head. If you draw the neck too straight or leaning out too far, the dragon won't look comfortable (and she might get crazy-mad at you!). The back will arch upward slightly. You can have the tail wind in front of or behind the dragon, whichever you choose.

2 The dragon's legs must look as if they're resting well on the ground while also slightly supporting her body, so she doesn't look as if she's going to tip over. Similarly to the sitting dragon, the knees of the hind legs will bend upward.

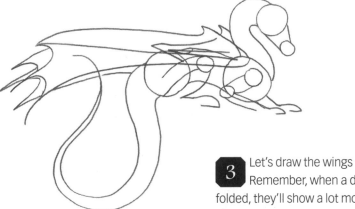

3 Let's draw the wings folded down. Remember, when a dragon's wings are folded, they'll show a lot more wrinkles. Plus, you won't have to worry about drawing in all the ridges, as some will disappear into the folds.

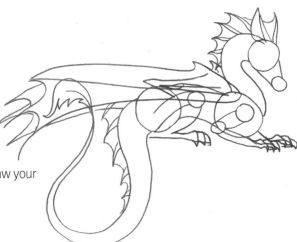

4 The layout's nearly complete. Draw your claws, ears, and spikes.

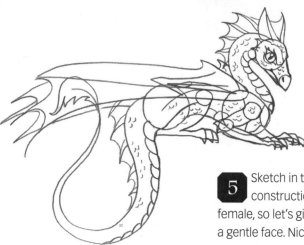

5 Sketch in the basic features over your construction lines. This dragon will be female, so let's give her large, expressive eyes and a gentle face. Nice.

6 Erase your construction lines and clean up your sketch for shading. Also, add a dark area under your dragon's belly to show that the other hind leg's tucked under there. Begin shading, adding some darker shadows under the wing folds and underneath the belly. If you want to draw a little dragon whelp sitting on her back, start the sketch for him as well, because his small claws will be overlapping her wings.

7 Continue shading and softening your lines. The darker you want the dragon to appear, the darker this base layer should be. Just make sure that you leave some nice, light areas for highlights.

8 After all that blending, the deep shadows need to be filled in darker again. Try using a B or even 2B pencil, as their softer leads will give you really nice, dark shades. (Be careful not to smudge your drawing too much if you do, as these softer leads smudge easily.) You may need to redraw your dragon's scales again after all that shading. That's OK! Personally, I usually end up redrawing the scales at least a couple of times for some drawings till they look realistic. Add a background and another little baby dragon, and your drawing's done. This mommy dragon looks as if she has her hands (or claws) full!

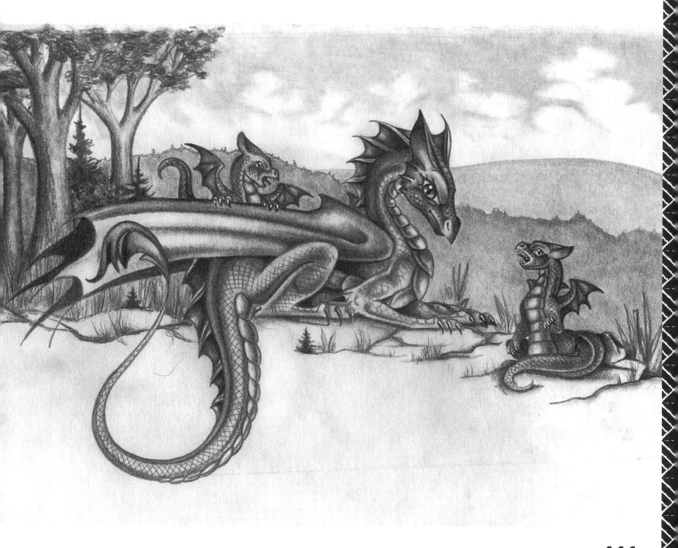

CURLED UP SLEEPING

Just like our pets, dragons enjoy curling up into tight, cozy balls when they sleep. It makes it easy for them to conserve warmth, takes up less space, and lets them guard their treasured items in the middle. (Mother dragons will often sleep like this, wrapped around their egg.)

1 The head will point slightly downward and the neck will curl upward to meet the body. The body arches up slightly and the tail curls back down and around, right underneath the dragon's chin. (This gives the dragon something nice and soft to rest her head on.)

2 When a dragon sleeps, her legs and arms often aren't visible, being tucked under the wings and neck to stay warm. So we'll go right to drawing the wings, which are folded down but spread out, not tightly compacted as in the previous drawing. Kind of like a nice, big, warm leathery blanket!

3 Now decide on the details you want to add, such as the type of scales and facial features. If the dragon's sleeping and not simply waking up, then her face will appear very relaxed and without emotion.

4 Clean up your construction lines, or copy your drawing onto a new piece of paper. Because this pose is so simple, it's a nice one to use to either add a pattern to her wings (as we did in "Unique Markings" in Section 3) or give her interesting scales. Let's give this girl smaller, platelike scales.

5 Begin your shading. Add dark shadows underneath the dragon's wings and tail, and blend in your pencil lines. Sketch in some leaves (or treasure, or pillows, if you prefer) for your dragon to sleep on.

6 Darken up the shadows a bit more, especially where the tail disappears underneath the dragon's wings. Finish blending your shadows together, and give your dragon a nice, sheltered spot to sleep. Notice how the details and lines of the scales disappear on the tail as it goes deeper into shadow. This is because, as light is absent, we can no longer see every line. It'll look more natural if you have the details disappear slowly like this where less light is hitting them, rather than trying to make the lines darker to show each and every scale.

RUNNING

Sometimes a dragon must run swiftly along the ground to remain stealthy, such as when hunting over flat, treeless terrain. Dragons can be extremely fast runners, and the trick to drawing them running is to make the wings as compact and tight to the body as possible. You'll find this is a really exciting (and challenging) pose to draw!

1 The dragon will stretch his body out as far as he can when running along the ground, to create the most aerodynamic shape. His neck will also stretch out, so when you draw your basic layout don't make the head raised much higher than the rest of the body, and draw the neck stretched almost straight out. The tail will usually stream out directly behind him as the dragon runs, though it will whip around when he turns quickly.

2 It's easiest to draw the dragon's hind legs in a more animal-like style for this pose. The hindquarters are large and powerful-looking, for pushing the dragon along the ground, and the forelegs (or "arms") are also fairly strong. So make sure you don't draw your circles for these limbs too small or too far apart. The wings must be folded as tightly as possible against the dragon's body, otherwise they'd catch the air and slow him down—or lift him off the ground!

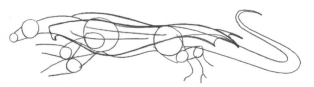

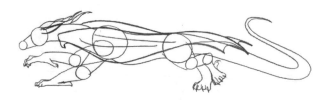

3 Feet and claws like those of an animal are probably best for this type of running pose. (Birdlike feet would be great for a dragon that runs on two legs.) The front claws can still be dexterous-looking, though, such as these ones. Just make sure they're not too dainty and that they look as if they'd function well for running.

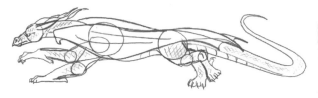

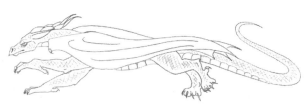

4 Add detailed items of your choice, such as eyes, and decide what type of scales your dragon will have. A dragon's ears will lie flat against his head when he's running (to keep from catching the wind), so whatever type you decide on should be leaning back, not pointing forward.

5 When you clean up your construction lines, you may need to erase the scales you drew in, as well. That's OK, as I usually find the first set of scales merely gives an idea of what type of scales will look good, and how they'll be drawn on the dragon anyway. Once you've cleaned up your lines, redraw the scales more precisely.

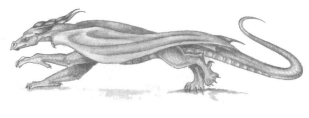

6 Begin your shading. Add darker shadows to the folds in the wings, underneath the wings, and on the underside of the legs. Smudge your pencil lines (you're keeping your blending stump handy, aren't you?), and continue to deepen your shadows.

7 It's important to gradually build up your shading so that your drawing doesn't become too dark and flat-looking. Once you've reached this step, though, it's time to start applying some much darker tones to the areas that need it. Just make sure that you keep your light areas *light!* Add a blurry-looking background to make it look as if your dragon's actually running fast, and then you're finished! The background should be streaking by in a horizontal direction, which makes the dragon seem to be zooming along.

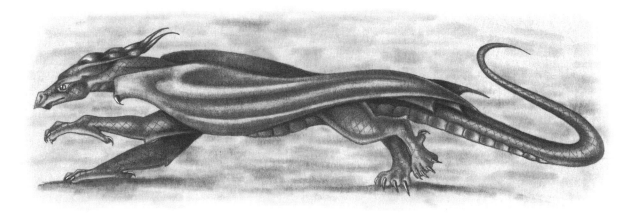

FLYING

You can draw a huge variety of poses for a dragon in the air—from soaring high in the sky, to swooping among the clouds, to darting toward an enemy. The possibilities are limitless. Taking photos of birds, or finding pictures online and printing them for reference only, are two *excellent* ways to get ideas for varied poses! Let's look at a dragon flying upward, as if she's just taken off.

1 Start by drawing the nose and head pointing upward. The body will also face upward and the tail will sweep down.

2 When a dragon's flying up, her wings will put a great strain on her shoulders, so her arms will either be held stiffly back or curled tightly into her body. This dragon has just now taken off, so one leg's up and the other is pushing downward.

3 Depending on how much room you have on the page, you can draw the wings fully extended or have them fold down a bit, as though the dragon's in midstroke. Let's draw these wings open but not fully extended, as though your creation's getting ready for a downward stroke.

4 Decide what type of claws and feet you want your dragon to have. Sketch them in, to complete your basic flying-dragon layout.

5 Fill in the rest of the details, such as eyes and chest plates. Because of the angle this dragon's drawn at, one eye will be barely visible on the top of the head, so we'll mostly be able to see the area under the dragon's jaw and throat.

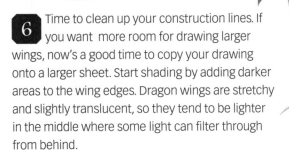

6 Time to clean up your construction lines. If you want more room for drawing larger wings, now's a good time to copy your drawing onto a larger sheet. Start shading by adding darker areas to the wing edges. Dragon wings are stretchy and slightly translucent, so they tend to be lighter in the middle where some light can filter through from behind.

7 Soften your pencil lines and continue adding tone to your dragon.

8 If you shaded your drawing too much in the previous step, erase some of the areas (such as the middle of the wings) to bring out your highlights. When shading, you can make your dragon look supershiny by creating higher contrasting highlights and nice, bright spots. Also add dark spots to the darker areas (such as along the tail). Then add a suitable background—and your masterpiece is complete!

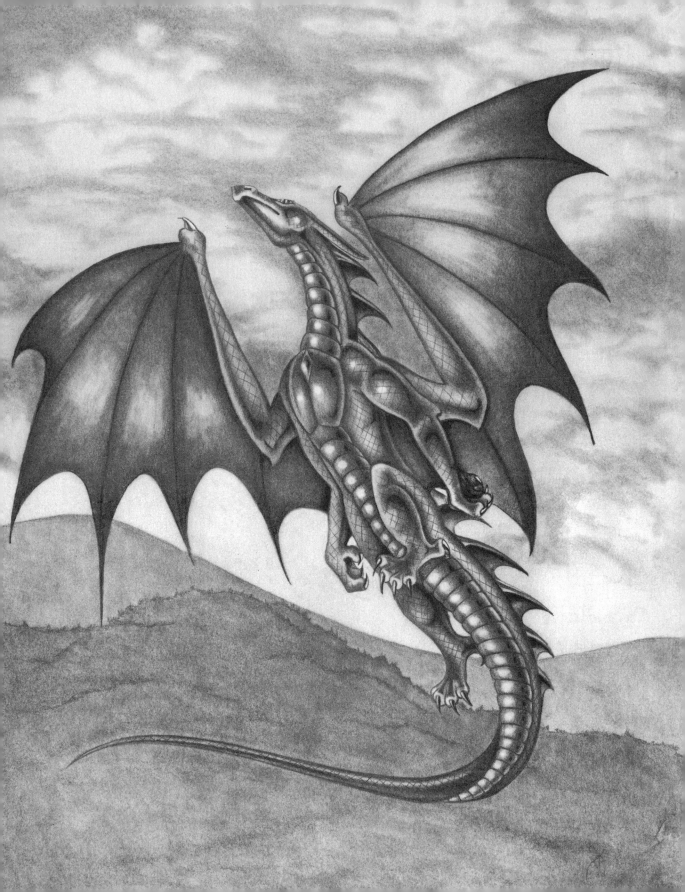

LANDING

Whether your dragon's landing gracefully onto the edge of a rocky cliff, or swooping down to grab a princess in his claws, you should note that he almost always lands on his hind legs.

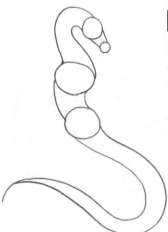

1 In some ways, this basic layout is the opposite of the pose of the dragon flying up in the air. The dragon's nose will point downward and the neck will curve forward. The body will arch underneath the head, being pitched forward as the dragon slows down. Finally, the tail will also whip forward to help balance the creature as it comes to a stop.

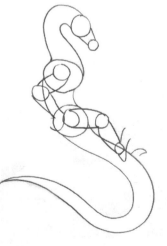

2 The dragon's hind legs must come forward for the dragon to land on, but they must remain bent slightly so he can absorb the shock of landing. The dragon's arms will pull tightly into his body from the strain the wings put on his shoulder muscles.

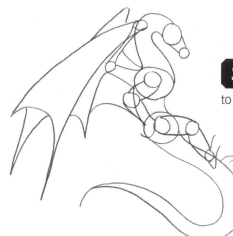

3 Here the wings are partially folded forward. The dragon is flapping them forward quickly to slow his descent.

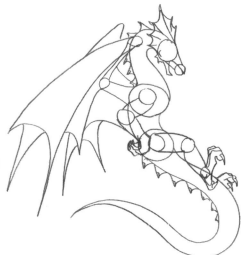

4 Your dragon's hind feet should be getting ready to grasp at the ground or whatever he's going to land on, and the claws will curl back. This dragon's mouth will be open, so sketch out the jaw and add any other defining parts, such as spines and head plates.

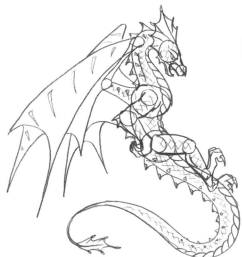

5 Try adding a few distinctive markings to your dragon. If you don't like them, it's easy to erase them. Try again or modify them to something more appealing.

6 The long, triangular markings look good on this dragon, so let's clean up the construction lines and get him ready to shade.

7 When starting to shade, the muscles should look as if they're bulging, since the dragon's working hard to slow himself down. So shade in some good defining areas around those muscles.

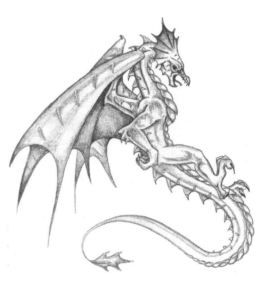

8 When you start blending your pencil lines, don't worry if your detailed markings become harder to see. You can always darken them up later.

9 The areas around the muscles will need to be darkened up again after smudging the drawing. Darken the dragon's stripes and scales too so they'll really show up—and your dragon's done, and beautiful! This dragon's meeting his comrades at some old ruins to plan their next campaign of terror.

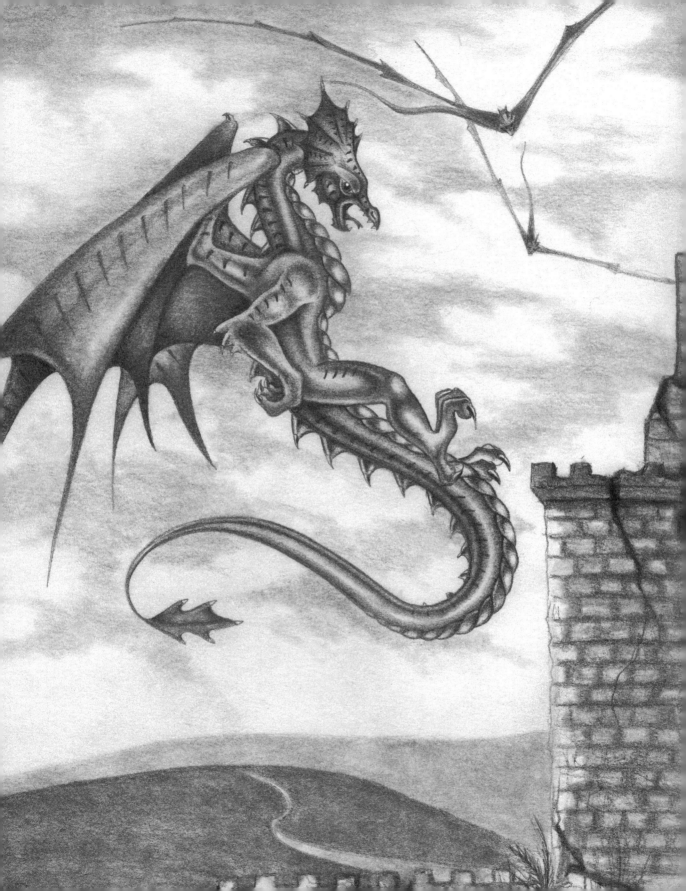

ATTACKING

Dragons often use their strong, powerful hind legs and claws against enemies (but you knew this already, in your skirmishes with dragons that have posed for you at home!). The dragon we drew landing in the previous section can easily be drawn as a dragon attacking something, simply by making him look angry. So, rather than repeating that pose, let's draw a couple of dragons facing off against each other in the air. We'll draw them from the back view so their legs and arms won't be visible (the poses for their limbs would be similar to the dragon either landing or flying, anyway). This way we can look at the dynamics of having two dragons flying at each other in a single drawing—an aerial combat scene!

The First Dragon

We'll draw this first dragon doubled over and looking down at his opponent.

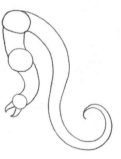

1 His back will be arched, so draw the head pointing downward and the neck curving up. The body continues upward and the tail can be positioned either going upward (as if the dragon's still flying downward) or curving drastically downward as in this example—almost as if the dragon was flying downward but has suddenly slowed his descent so as not to collide with the other dragon.

2 Because this dragon is attacking, he's pulled his wings closer into his body (while still keeping them extended enough to fly). This leaves them less vulnerable to attack, which is critical, since he clearly can't fly without them.

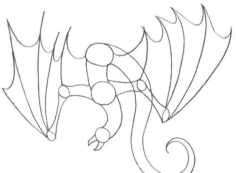

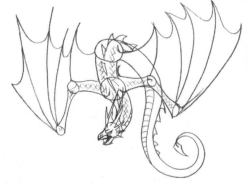

3 You don't need to draw any limbs or claws if you don't want to, since with this pose they're implied. That is, we know the dragon has them, but they're hidden behind the wings. So you can go ahead and figure out what other details you want to add, such as completing the face and scales. Your dragon should look *angry*—make sure he isn't smiling! Your layout sketch is now complete.

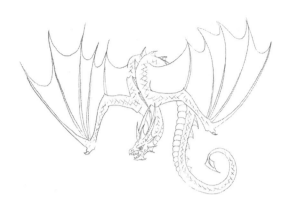

4 Rather than cleaning up the layout sketch, I'm going to trace this drawing onto a new, large piece of paper that has room for both dragons. The easiest way to do this is with a "light box." If you don't have one, you can simply tape or hold your drawing and a clean piece of paper against a day-lit window, which is how I used to transfer my drawings for many years! If you do this, make sure there's no risk of your falling through the window, and don't press too hard against the glass. *Always be safe*. (Drawing dragons shouldn't be a dangerous sport, though partying with them definitely is!)

IT'S COOL TO USE A LIGHT BOX

A light box is simply a box that has a light source in it and a translucent piece of flat plastic or glass on the top that the light can shine through. It's a tool for tracing your drawings. You can buy one online or at an art store, or make one yourself.

5 Begin blending your pencil lines together with a blending stump or your finger. We'll have to erase some shading later in the final step, but for now just focus on blending your pencil strokes, and continue to darken the dragon's shadows.

The Second Dragon

This fierce attacking dragon will be looking up at the other dragon and will be positioned as though he just flew up to wage war with him.

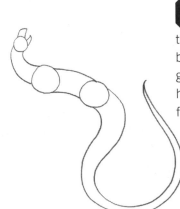

1 Because this dragon isn't facing downward, he won't be doubled over himself. So start the head facing up and then have the rest of the body flow down toward the ground (thanks to gravity). The tail can swing back up if you like, however, as dragons tend to whip their tails around furiously when fighting.

2 Once again, the dragon's legs and arms are protected and pulled tightly into his body, and not visible through his wings. (Dragons often use their hind legs for fighting, but in this case they're just starting to face off. They'll mostly use impressive aerial displays and ear-piercing roars to intimidate the other.)

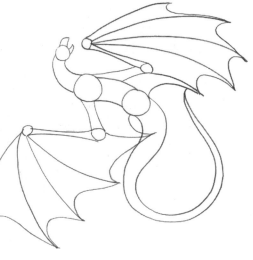

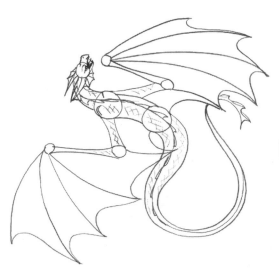

3 Finish your basic sketch by drawing the dragon's head and scales. This dragon's back is toward us, so continue the spikes along his spine right down the back and tail.

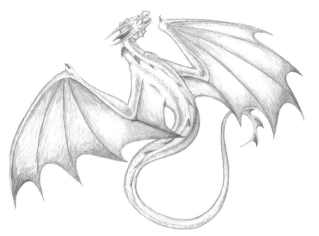

4 We're ready to copy this dragon onto the larger piece of paper alongside the first dragon. (Use your light box or day-lit window technique.) Position him below the other dragon and slightly to the left, so that they look as if they're snapping at or confronting each other. When you start shading, keep in mind that both dragons need to have light hitting them from the *same angle*, so your shading on this dragon should match the shading on the first one above it.

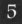 **5** Once you've smoothed out your second dragon, you can start adding a background.

YOUR SPLENDID DRAGONS
ARE COMPLETE!

Let's do a dark, celestial background. There are certain issues involved with doing a very dark background such as this, the first one being time. A background like this one will be extremely time-consuming, so make sure you're not in a rush before you start it.

Second, a dark background can be quite messy and easy to smudge, so have a spare piece of paper to use as a "shield" from your hand. (Most great artists use such a device.)

Third, you'll find that your shading that looked marvelous on the dragons before you started the background suddenly looks too light and dull. This is because the background is so dark that your shadows on the dragons need to be made darker as well. So don't be surprised if you find yourself going over the dragons again with your pencil, to darken things up somewhat.

Finally, just as you had to darken up your shadows, you'll need to lighten up your highlights. Feel free to use that eraser! In fact, you may find that areas you had originally shaded in dark would now look better light (such as in this drawing along the back of the dragons' wings). Add some really bright highlights to such areas as the top of the dragons' heads to make it look as though moonlight is glinting off their scales. Take care to have the light coming from the same direction for *both* dragons.

Now you're ready to explore the world of some exotic dragons that will thrill and delight you. Get ready to meet (and draw!) Oriental dragons, sea serpents, fairy dragons, wingless drakes, and snakelike amphipteres.

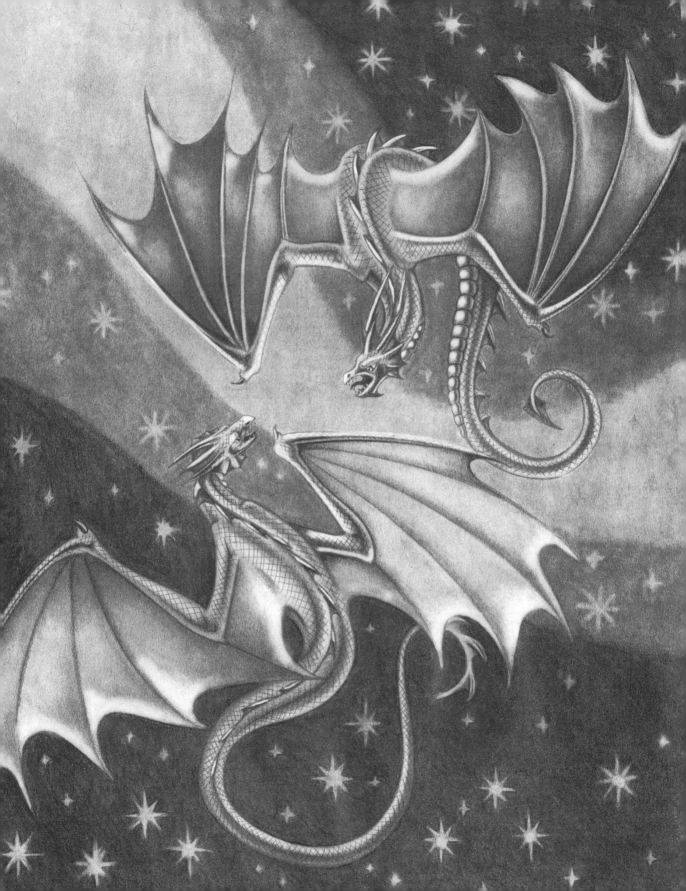

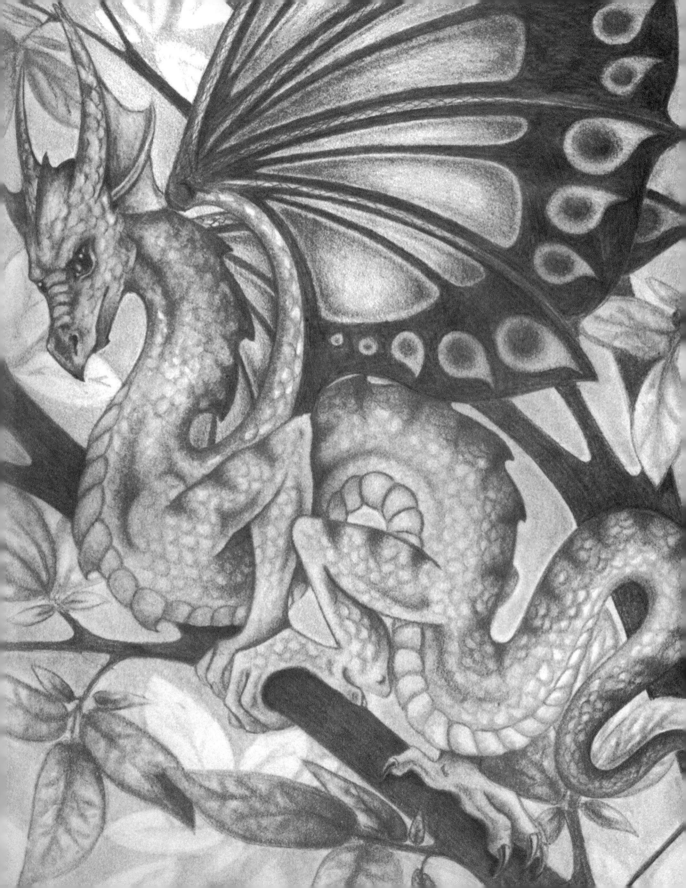

Section 5

ENCOUNTERING UNIQUE DRAGONS

Some types of dragons are characterized by how many legs or body parts they have, such as *wyverns* (dragons that only have two hind legs), *wyrms* (dragons that have snakelike bodies with no legs or wings), or *hydras* (dragons sporting two or more heads).

Other types of dragons are entirely unique, with characteristics all their own. Examples illustrated in this section are sea serpents that spend all their lives in the water, and tiny fairy dragons that proudly show off their butterfly wings and antennas.

You can add any number of characteristics to your dragon to make him—or her—a truly distinctive type of dragon. You might want to give him robotic limbs or a centipedelike body, for instance. For now, though, let's take a look at some of the special types of dragons that we've heard about in stories and legends. Later, as you gain experience and confidence, you can modify these fabled types—and even create ones entirely your own. Happy dragon hunting!

ORIENTAL DRAGON

If you love dragons, you'll find many types of dragons living and bringing people good luck in the Far East—primarily in China, but in other countries as well, such as Japan, Korea, Vietnam, and Malaysia. Eastern dragons share a number of similar qualities. They're usually benevolent, wise, creatures associated with an element of some kind (such as water) or with the weather.

They possess long, serpentine bodies that twist and curve, as well as rounded, fishlike scales. Most Oriental dragons lack wings, but still have the ability to fly using their magical powers. Depending on which region the dragon comes from, they'll have a varying number of claws. A Japanese dragon, for instance, has only three claws on each foot, while the Chinese Imperial dragon of legend has *five*.

Let's now take a look at drawing an exotic and most beautiful Oriental dragon, though we won't worry about exactly what region he's from.

1 This dragon has no wings but can fly through the air magically, almost as though he's swimming through it. So let's draw him flying downward. When starting your basic body layout for an Oriental dragon, the neck and body will be very long, so make your circles far apart. The body should be quite curvy and twisty, even doubling and looping over itself in certain areas (such as by the tail).

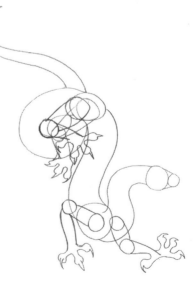

2 An Oriental dragon's arms and legs bend like those of a bird, though the hind legs are usually thicker around the thigh. Add some claws. Typically, Japanese dragons have three claws on each foot, Korean dragons have four, and Chinese Imperial dragons have five.

3 Let's take a close look at the head, as Oriental dragons have lots of unique features here. First off, they usually have long whiskers coming from atop their nose, as well as thick beards around their face. They have rounded eyes with round pupils (not slits or cat's eyes), and they also have shorter, rounded ears. Their horns are very antler- or branchlike, and their noses tend to be more rounded and flat with quite pronounced nostrils.

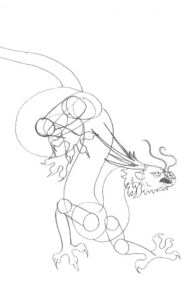

4 Now finish adding the rest of the details. Oriental dragons have strong-looking, well-defined paws that are usually stretched out and that end in dangerous-looking talons. Their mane of long and heavy hair continues down the spine and ends in a thick tuft of hair at the tail tip.

5 Clean up your drawing and erase all the construction lines.

6 Oriental dragons are covered in very defined, fishlike scales, and you'll need to draw each one individually! (It will pay off.) It helps to lightly draw in a grid pattern underneath, so that your scales will follow a consistent pattern.

7 Begin lightly shading your drawing. Add a bit of a shadow underneath the eyebrow so that he doesn't look so "wide-eyed." You want him slightly mysterious.

8 Blend your pencil strokes together, using your blending stump if you wish. Don't worry if your dragon's scales get blurred a bit in areas, as you can always draw them in again. Anyway, the scales shouldn't be perfectly visible in the really dark shadows and areas.

9 Darken up your extra-dark shadows—and then you're finished! Oriental dragons are often seen holding onto (or with) a pearl, which gives them magical power.

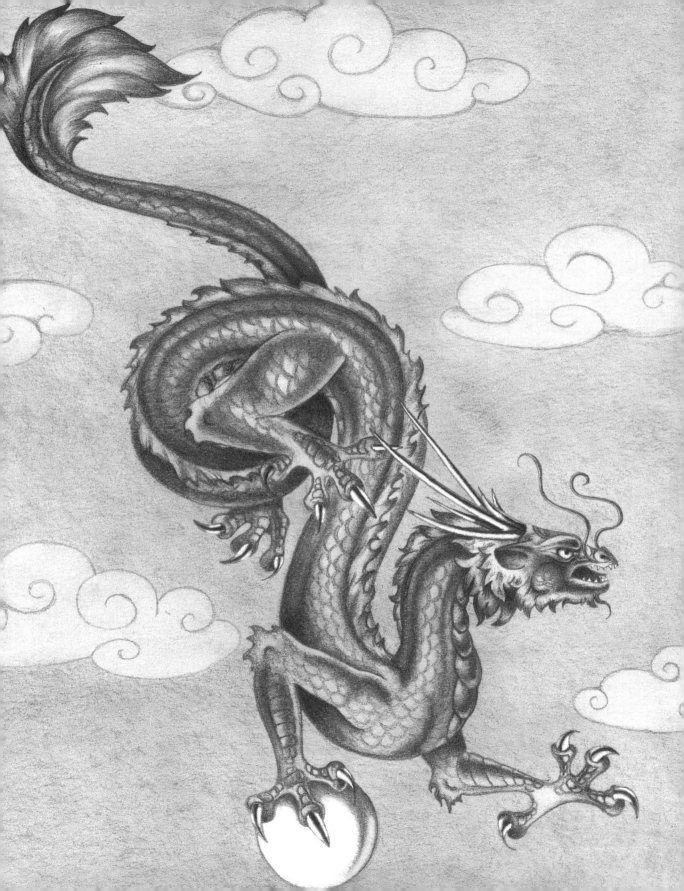

SEA SERPENT

The dragons known as sea serpents are huge, snakelike, sinuous creatures that live strictly in the water. Hundreds of sightings have been made of these creatures all around the world throughout history—some even in the last century—though they seem to be really good at hiding when we try to actually find them! They have long, powerful, whalelike tails and often have fins and flippers, as well. You don't have to travel to Scotland's notorious Loch Ness to spot a sea serpent—you can just draw your own!

1 Begin your basic layout for a sea serpent with the head and a superlong neck! Because a sea serpent has no legs, we only need to draw one circle for the torso (not including the two circles we drew for the head) to show where the neck ends, and also to give us a spot to add pectoral flippers to. A sea serpent's tail is long and usually loops back under the water, so even though we're drawing the entire length of the body here, eventually some of it will be underwater. Finish your serpent off with a tail like a whale's (which you've probably seen on TV, or even in real life out on a boat).

2 Add prominent fins along the serpent's back, and your basic layout is done!

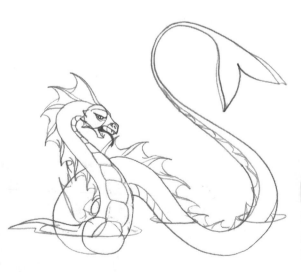

3 Sketch out the dragon's face. Sea serpents (at least, the ones I've known!) usually have blocky-looking heads but no ears. Add a flipper partially coming out of the water, once you decide where he's going to be positioned in the water.

 4 Now you can clean up your sinuous sea serpent and get him ready for shading.

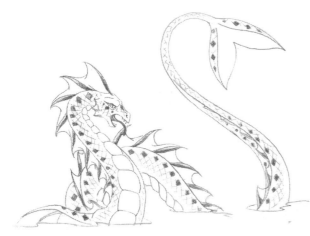

5 Because there isn't much to a sea serpent (no legs or wings), it may be nice to give him a bit of a pattern to make him more interesting—and maybe more attractive to a lady sea serpent! Let's give this fellow a diamond pattern along his back. Make sure the diamonds match up with his scales, though, so draw the diamonds first.

6 Begin shading your serpent. Give him highlights along his body where the muscle bulges out a bit, to show that though he's long and thin, he's still tremendously strong and the king of the sea!

7 Soften some of your pencil lines and fill in more of the white areas. Then darken up your shadows and recesses along his body, so that he looks really shiny from slithering through the water.

8 *(See next page.)* Finally, add water around him and a bit of a background for an attractive finish, and then you're done! When drawing water, remember that it's highly reflective, so make it darker around the sea serpent and close to the shore.

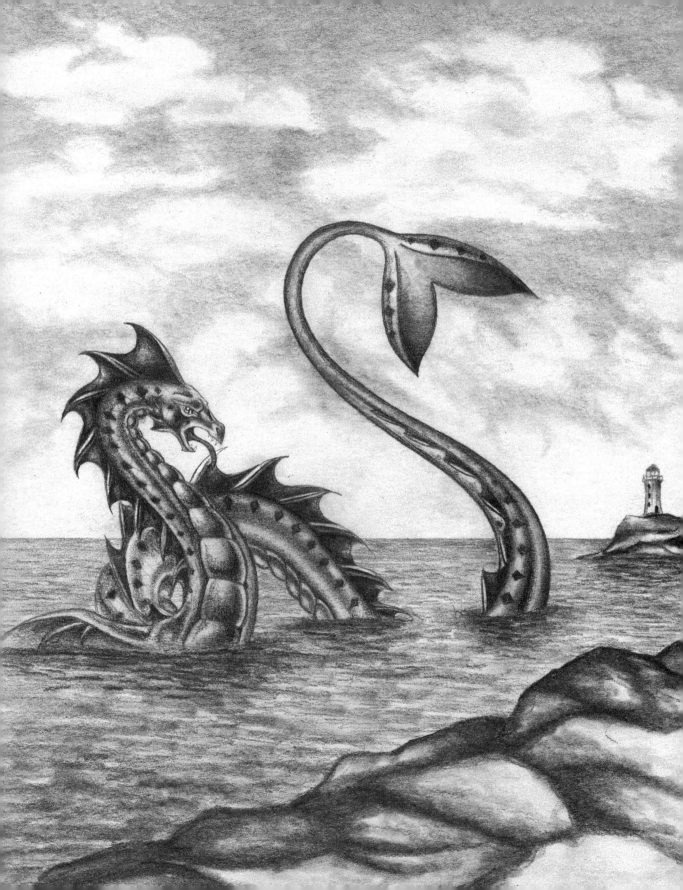

FAIRY DRAGON

What kind of tiny dragons love flitting among flowerbeds and resting their wings in the sunshine? Why, fairy dragons, of course! (You may even have spotted them in your garden, especially in the early morning and at twilight.) Their wings are insectlike, often similar to butterfly or moth wings —or those of, well, dragonflies! They're incredibly small, so it's a good idea to draw them with a background that shows how tiny they are, such as dancing among flowers or resting on bushes.

1 The basic layout for a fairy dragon is very similar to that for a "regular" dragon (which, since you've now gained so much experience, may seem a bit too easy for you!). So start by sketching a long arched neck, two circles for the body, and a long, curving tail.

2 Add your basic shapes for arms and wings. Fairy dragons are usually small and dainty, so make sure the limbs are, too! You don't want to make them blocky and heavy.

3 Add wings to your little dragon. We'll give her butterfly wings, but you can use pretty much any insect wings, though they most commonly mimic butterfly or moth wings. Or, if you're drawing a *dragonet*, which is just a miniature dragon, then you'd draw regular dragon wings.

4 Add in your details for your fairy dragon, such as patterns on the wings and face, plus little antennas (to pull in signals from space? to listen to your cell-phone calls? who knows?).

5 Clean up your drawing, or copy it onto a fresh piece of paper. Fairy dragons *love* collecting things (or stealing them right out of your room!), so give your little girl dragon something to hold onto—say, some leaves or a feather.

6 Begin shading your dragon and decide what areas on the wings you want to shade. It usually looks better to have the wings a darker shade with lighter spots on them than the other way around.

7 Smudge your pencil strokes, especially in the wings where you want a nice, consistent tone to make their surface look soft and light. Now begin darkening up your drawing where the shadows need to be deepened. Give your drawing really nice contrasting tones between the dark shadows and the bright highlights. Soften up the wings again by smudging (if you need to). Don't be surprised if you need to erase the white areas in the wings to get them really white again. Finally, you might add a background of leaves or flowers to show just how tiny and delightful your fairy dragon is, and to give her an interesting place to explore!

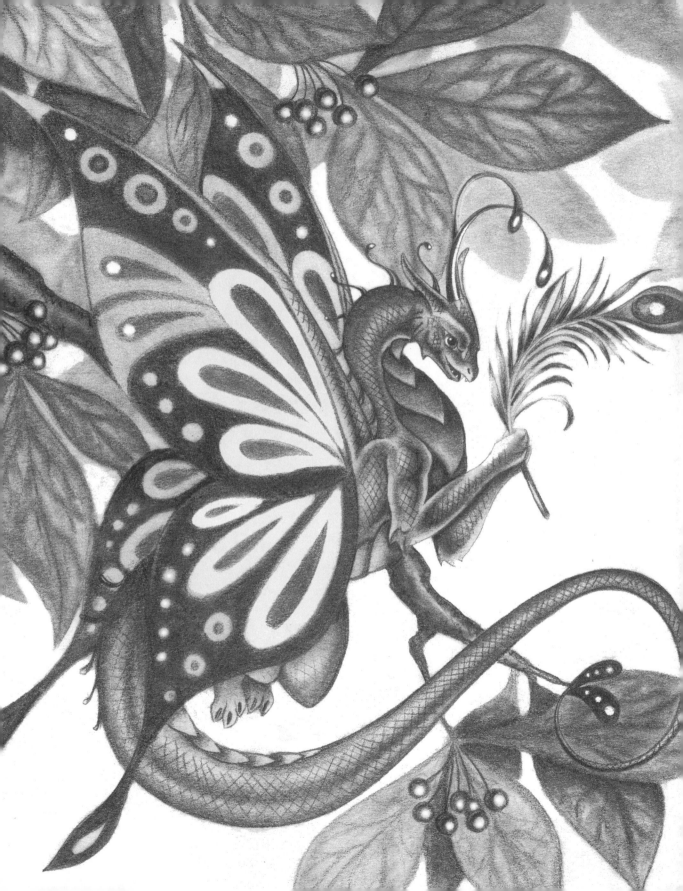

DRAKE

If you spot a scary-looking, wingless dragon coming at you, it might be a drake. So watch out! These dragons have no wings and are very lizardlike (kind of like they were crossed with giant iguanas centuries ago). They're really large and are commonly associated with either fire or ice (you got your hot drake, or your cold drake!). Drakes are more closely associated with Western dragons than Eastern dragons and are usually fierce, malevolent creatures.

WHAT'S UP WITH DRAKES?

Curiously, "drake" comes from the Middle English word for "dragon," which in turn derives from an Old English word, "draca," and can be traced back to the Latin "draco" and Greek "drakon." (A drake is also a mayfly, used as fishing bait.)

1 Since drakes are large, powerful dragons, their necks will be short and thick, and their bodies broad. So draw a larger circle for the chest than for the hindquarters.

2 To give your drake muscular, sturdy legs, make sure they're thick. The front legs bend more like animal legs than like arms, and the hind legs have broad thighs and small calves.

3 The claws should be thick and end in razor-sharp talons, almost like a mix of a lion's paw and an eagle's foot and talons.

4 When drawing the face, keep in mind that your drake's more lizard-looking than most dragons, so give him a flatter head, cold and impersonal eyes, and a long, forked tongue. Add thick, dangerous horns and knife-sharp teeth to make this fellow look superdangerous.

5 Finish up your basic sketch by determining where you want your muscle lines. Why not add some unfriendly-looking spikes along your drake's back?

6 Erase your construction lines or copy your drawing onto a new piece of paper.

7 This drake has large, platelike scales. Draw them thicker around the base of the neck, with smaller square ones just below. Don't draw any on the underbelly or under the neck, though, as the hide will be finer and smoother there, as on a crocodile or alligator.

8 Begin shading, adding highly contrasting dark areas and light areas to the horns and spikes to make them look shiny.

9 Smooth out your shading and work on giving your entire drake's body a good, solid tone.

10 To make the scales stand out well, keep them lighter and then add darker shadows underneath and around them. Darken up your shadows underneath the drake's belly and legs, add a background (like a pale moon looming over a distant castle), and then you're done. Man, that's one awesome scary-looking drake!

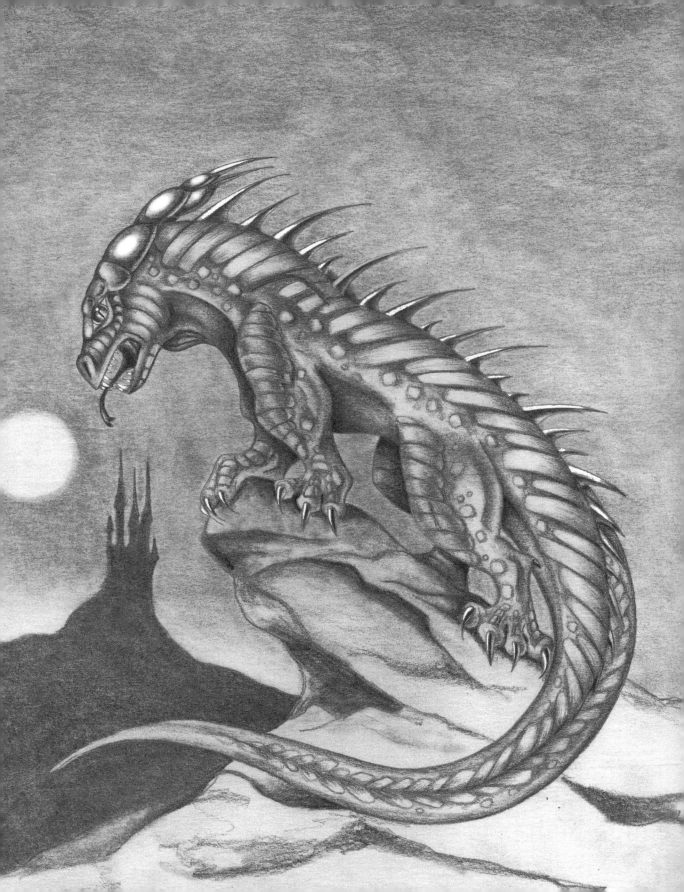

AMPHIPTERE

If you can say "*AM-fip-tair*," you can probably draw an amphiptere by now. Also called a *jaculus*, this strange beast has a sinewy, snakelike body and wings, with no legs at all. If it has to touch down, it clings to a branch or other object with its snaky body instead of a claw or limb. Its wings are typically feathered, though they don't have to be.

1 Drawing the basic layout for an amphiptere is similar to drawing one for a sea serpent. They have long, curving necks, so you only need to draw one circle for the body, to give a focal point to attach the dragon's wings to. The tail will also be long and winding and will slowly taper off to a fine point.

2 Decide how you want your dragon's wings posed (such as fully opened or partially opened), and also whether you want feathered wings or wings like a bat's. Because this dragon is very simple, let's add feathered wings to make her a little more interesting to draw.

3 Sketch out the face and chest plates. Since this dragon is serpentlike, she won't have ears, but *can* have interesting horns or spikes running down her back.

4 Now sketch the feathers and scales for your amphiptere. The flight feathers should be quite long and spread out evenly, while the rest will be shorter and will overlap each other.

5 Clean up your drawing. Add a pattern running along her back, if you wish to make her a bit more distinctive.

6 Begin your shading. I added a pattern of small triangles down her back, so when I started shading the wings I also added the pattern along her flight feathers, and gave her darker feather tips as well.

7 *(See next page.)* Blend some of your pencil lines together. But be careful not to blend *too* much over the highlighted areas, as amphipteres should look rounded and snakelike. Darken up the shadows under each feather, to give the wings a lot of volume. (They'll need it, so that our amphiptere can swiftly swoop down on her prey!) Draw a thin line straight down each feather, then draw smaller lines angling downward off that line to give the feathers some texture. Almost done…. If you unintentionally smudge your drawing as much as I often do, try erasing the ends of some of the smaller feathers to make them stand out once more against the rest of the wing.

Some amphipteres are said to live on alternate planes of existence where they watch over our world. Kinda like a Facebook or YouTube for dragons? Maybe this beautiful (but frightening) lady is doing the same!

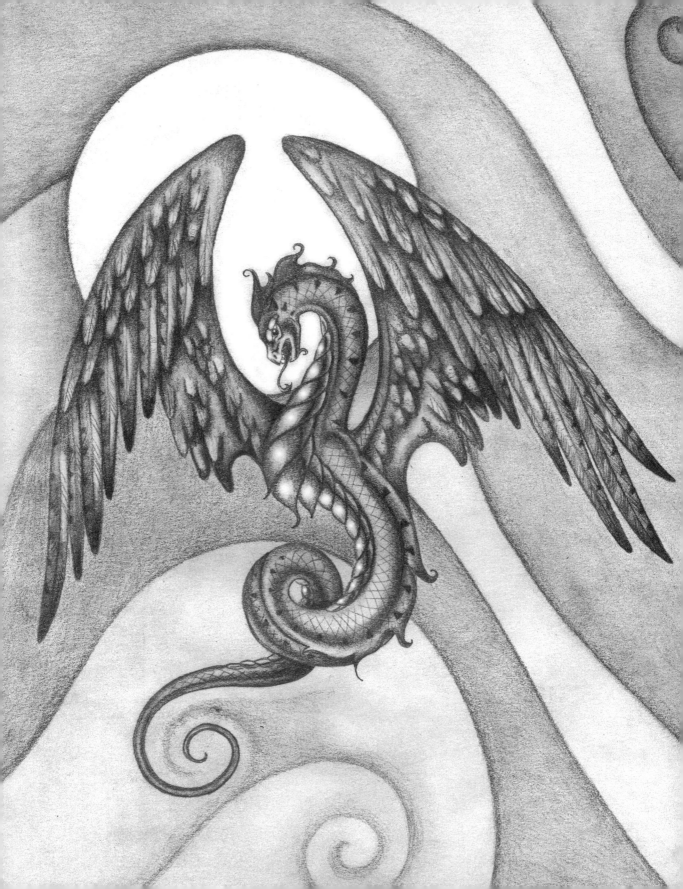

LAST WORDS

You are now officially a dragon-drawing expert! I congratulate you on working hard to learn some new drawing techniques, while exploring the fascinating world of dragons. I truly hope you enjoyed going through this book as much as I did creating it, and I trust it was helpful.

If there's one piece of advice I can leave you with now, it's this: practice, practice, *practice!* You may be surprised at how much of a direct relationship there is between the amount of time you spend on drawing and how good you get. (Even today, some thousands of dragon drawings after I drew my first one as a teenager, I now and then still get stuck on certain poses!)

Whatever you do, don't give up just because a drawing doesn't turn out perfectly the first time. Keep sketching, and eventually you'll get it to where you want it to be. Drawing shouldn't become a chore for you, so if you get tired take a break for a bit. (I've put down drawings for years before picking them up again, so if that's what you need to do to move on to the next drawing, then that's OK!)

Good luck. And be careful when asking dragons to pose for you (before you do, make sure they've already eaten). And, most of all, have fun!

All the best…

Sandra

ABOUT THE AUTHOR

Sandra Staple was born and raised in Halifax, Nova Scotia, Canada, where she now lives with her husband, Jason, and their daughter, Chloe. Her mother is a local artist, and so Sandra has been drawing and painting since she was a young girl.

Her passion for art earned her an award for Excellence in Art in high school, as well as awards of distinction in both English and Art. She went on to graduate from Saint Mary's University with a major in computing and information systems, as well as a minor in creative writing.

During her years at the university, Sandra started a website that would later turn into a large personal gallery, at *www.canadiandragon.com*, which receives tens of thousands of visitors each week.

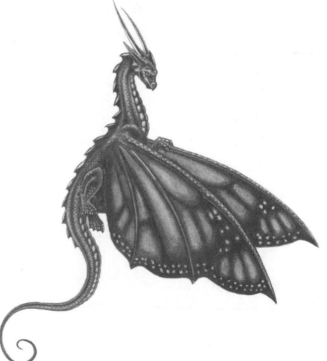